DRAWING YOUR OWN PATH

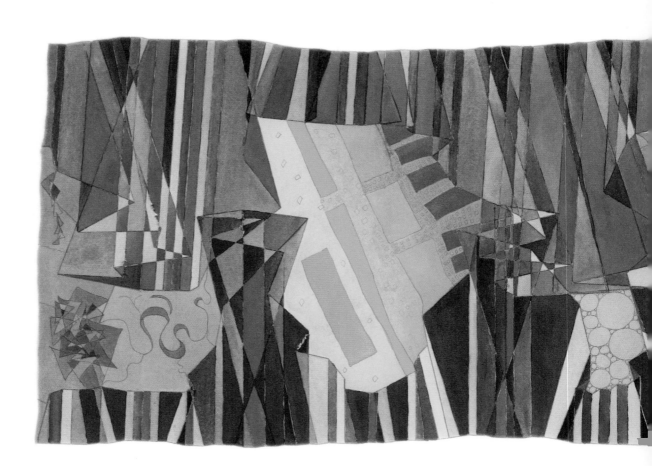

DRAWING YOUR OWN PATH

33 Practices at the Crossroads of Art and Meditation

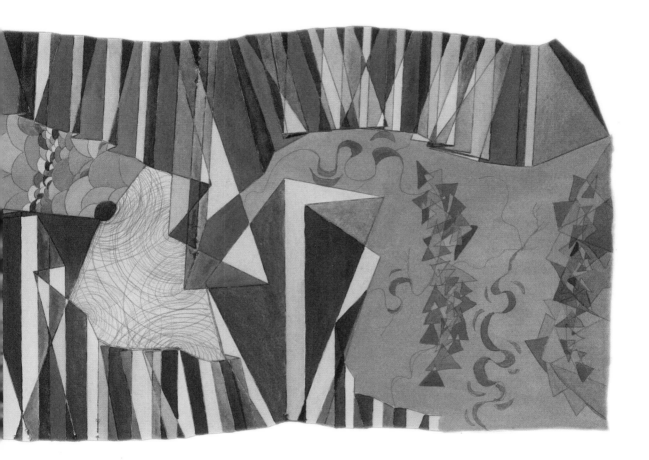

JOHN F. SIMON JR.

PARALLAX
PRESS

Berkeley, California

Parallax Press
P.O. Box 7355
Berkeley, California 94707
parallax.org

Parallax Press is the publishing division of Unified
Buddhist Church, Inc.

Cover and text design by Debbie Berne
Cover image © John F. Simon Jr.
Author photo © Elizabeth Simon
All other artwork © John F. Simon Jr.

Art on page 89: Klee, Paul (1879-1940) ©ARS, NY.
Seiltaenzer (Tightrope Walker). 1923. Lithograph.
44X26.8 cm. AM81-65-872 ©CNAC/MNAM/Dist.
RMN-Grand Palais/ Art Resource, NY

Some text in this book was originally published in
Mobility Agents: A Computational Sketchbook. Other
sections and captions herein may contain text that
originally appeared as part of my daily writing on
iclock.com.

ISBN 978-1-941529-36-2

Library of Congress Cataloging-in-Publication Data is
available upon request

1 2 3 4 5 / 20 19 18 17 16

This work is dedicated to the creative spirit
and all those who embrace it.

PG 86

contents

Introduction *9*

1

Wrong Question, Right Answer *13*

Practice One. Getting Right Into It

Practice Two. Watching Your Hand

Practice Three. Marking Practice

2

Realistic Drawing *25*

Practice Four. Picking an Object to Draw

Practice Five. Attentive Looking

Practice Six. Noticing Awareness

Practice Seven. Marking from the Sense of Sight

Practice Eight. Simple Rendering

Practice Nine. Try Perspective

Practice Ten. Working Inward

3

Systematic Drawing *53*

Practice Eleven. The Circular Arrow—A Visual Mantra

Practice Twelve. Improvising Between Two Points and
Finding The World In-between

Practice Thirteen. Thought as Art

Practice Fourteen. All Four Pixel Images

Practice Fifteen. Book of Compositions

4

Improvisational Drawing *83*

Practice Sixteen. Going Outside the Box

Practice Seventeen. Not-breath Awareness

Practice Eighteen. Growing Improvisation

Practice Nineteen. Chasing the Coltrane Effect

Practice Twenty. Drawing to Reveal Inner Conditions

Practice Twenty-One. Noticing Intuition

Practice Twenty-Two. You are the Universe Drawing

5

Reading The Drawings *115*

Practice Twenty-Three. An Exact Physical Description

Practice Twenty-Four. Feeling the Meaning

Practice Twenty-Five. The Story We Tell Ourselves

Practice Twenty-Six. Connecting Our Story to a Larger Story

6

The Search For The Source Of Creativity *137*

Practice Twenty-Seven. Priming the Source

Practice Twenty-Eight. Sitting Still at the Origin

Practice Twenty-Nine. Embedded Sources

Practice Thirty. Mindful of the Path

7

Meta-Drawing *163*

Practice Thirty-One. Sharing with Yourself

Practice Thirty-Two. Sharing with a Trusted Friend

Practice Thirty-Three. Sharing with the World

Recommended Reading *185*

Acknowledgments *186*

About the Author *189*

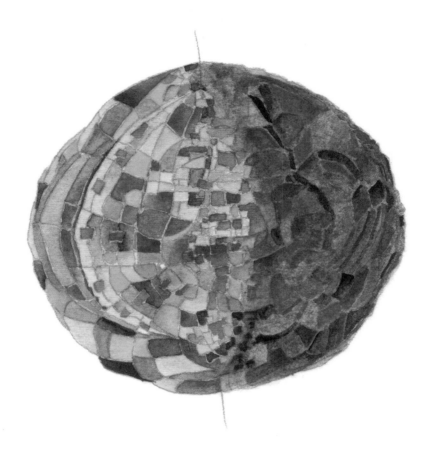

Global Perspectives
04.30.2009

Morning and evening stepping back,
I watch the world from far away
Then bring the distance home.

As I prepared to hold a workshop on contemplative drawing at the 2014 Buddhist Geeks Conference, my only concern was how I could best convey my topic to an audience of meditators. I have a lot of experience teaching artists, guiding them toward the source of their creativity, and helping them find their motivation for making things. I also maintain a regular drawing practice that is my own path to meditation. However, for this group, I felt like I had to approach the topic in the opposite way, asking experienced meditators from a variety of traditions to start with mindfulness and then examine what arose as they made drawings.

As the workshop got underway, I asked the participants to pick up pencils and begin to freely make marks. When I invited everyone to notice resistance, the so-called inner critic, there were a few quiet gasps. Some people hadn't been able even to begin. Being with so many experienced meditators was an exciting moment, and I felt like we'd found the first edge to work with. The workshop kept going and everyone completed a variety of practices—many of which are described in this book—and to my delight, the resonance was strong and the feedback was warm. I had known the contemplative and creative paths were compatible, but when I worked with this group I was amazed at how closely the practices and teachings aligned. The connections I made that day showed me that a wide variety of people could understand a mindful drawing practice, and I felt an obligation to share how this practice can enrich the creative life.

The book's seven chapters lay out the components of a path that I began to follow unknowingly, finally woke up to, and still follow today, over sixteen years of daily practice. The method I describe works for me in visual art but it was tested in a new context as I shifted to writing this book. Along the way I encountered more

than one inner critic blocking my words. I took my own advice: I went back to first principles, followed my breath, stayed in the moment, allowed words to arise, and I found my way through.

The first four chapters introduce various forms of "making," and the practices involve a lot of drawing. I describe a variety of ways to draw and I imagine that you will try them all; but for your "main practice," you will probably settle on one style that works best for you. Or maybe you'll just continue the way you already draw but find a way to incorporate mindfulness. You might be like me and continually practice everything, sometimes in the same drawing. Doing creative work every day is what's important, not the style you choose.

Chapter One will help you begin choosing materials and will offer the first lessons in what to notice as you draw, covering the first combinations of mindfulness and mark-making.

Chapter Two discusses realistic drawing; you can think of the practices presented there as concentration-style meditations. Try to get absorbed in the thing you are drawing. Take your subject as an object of meditation. Chapter Three's practices ask you to make visual mantras, deepening meditation with repetitive tasks. The discussion in Chapter Three ranges widely into Conceptual Art and computer software. If it seems a bit far afield, please hang in there—I think you will see it shows the limits of automation and that creativity can't yet be captured by digital systems. Chapter Four's improvisational drawing method offers something similar to an open-awareness style of practice, learning to be open to whatever wants to be drawn on the page.

Chapter Five shifts us into an insight style of meditation. We learn to "read" our drawings by turning our attention inward and thinking about what is being transmitted both consciously and unconsciously. We practice freely, making up stories and trying to explain our work as a means of revealing the identities we cling to. The common thread is not a single way of thinking but learning how creativity facilitates insight.

In Chapter Six we pull back and look at the cycles that form naturally in an active creative practice, trying to see creative work from a very wide perspective.

I introduce two maps: Joseph Campbell's "hero's journey" and the historic Ox-Herding Pictures, ten illustrations showing the levels of realization in Zen Buddhism. Through them I show how to recognize transitions along the path, negotiate the changes, and discuss what values each map emphasizes. Chapter Seven leads us from the studio into the outside world, stresses the necessity of sharing our creative work with others, and discusses how creative practice integrates into one's daily life.

Each chapter is illustrated with drawings made using the practices I describe in the book. I create these kinds of artworks every day by sitting down, not knowing, and allowing whatever happens to appear on the page.

This book will guide your steps, but there is no way to make a good drawing by simply reading about drawing—just as you can't prepare a delicious meal from reading a cookbook. To learn to cook, you have to go in the kitchen, chop, mix, and season; to understand drawing, you have to draw. Among the chapters I include thirty-three hands-on practices, real things for you to do with pencil and paper. What you experience when drawing cannot be conveyed in words. Yes, I tell some amusing stories and give my theories about what is going on as you practice, but it is only by picking up a pencil, setting your intention, and doing the practices that you will see what I mean. I promise there is something amazing to discover.

—John F. Simon Jr.

Discerning the Rules
02.22.1999

1
WRONG QUESTION, RIGHT ANSWER

With the crowd at my art opening thinning and heading to the after-party, hors d'oeuvres finished, compliments paid, big sales closed, and the staff starting to unwind, a visitor to the gallery approached and began to tell me about how strongly he reacted to the work. Fred was a software engineer with a flair for graphics and always wanted to make art; he loved visiting art galleries and museums but couldn't decide if he was going to be an artist. At present, he had no desire to switch careers since he was in high demand and well paid as a programmer. Knowing there would never be enough time to devote to making art, he disparaged initiating his own creative projects since he was sure his beginner's flailing would be a waste of time. He was looking for me to give him a reason to justify spending more time on a growing passion that could yield no predictable professional results. Maybe he thought I knew a secret, because at some point he stopped talking and asked me directly, "If I want to make a good drawing, do you have any tips for how I should go about it?"

Ego-inflated from my opening night, flattered by his question, and slightly tipsy from the wine, I began to pontificate. I gave him my views on how one would make a good drawing, only to hear all my theories second-guessed in my mind as quickly as they were spoken. The generalizations I made to him about color and composition kept missing the point. I flailed, sputtered, and eventually realized, but not until nearly ten years later, that the answer to his question was in the question itself. We'll discuss this further later, but for now, let's begin.

Getting Right into It

How do you begin? What is required? Let's skip the lengthy introductions and theories for now. All you need to begin is something to make marks with and something to mark on. Act now while your interest lasts—take up the nearest pencil, grab a pen from your desk drawer, or choose a marker from that holder in the kitchen next to the phone. Now scribble on an old envelope, on the back of a box, or make a few doodles in the white spaces of this page. It will only take a few seconds. Just start making marks! Lines, curves, curlicues, scribbles—whatever strikes your fancy. Just doodle some marks on a page. Now try and remember what it was like when you were young, and imagine you are back there now. Let go and draw like a child. *It doesn't matter what you draw but what you feel.* Let yourself laugh or at least smile. No one will ever see this, so draw like you haven't drawn in years.

Did you scribble a few marks? How long did you fuss over your choices of tool, paper, and location? Do you like what you see? Was it fun? Scary? Stupid? Liberating? Other things? Did you manage to let go? Did the thought cross your mind that this practice was pointless? Did you hesitate or did you begin making marks right away? Did you find a moment of flow when you did not know what marks were going to appear? Were you surprised by what you saw? Or did you not give much thought to what you were doing at all?

Beginning my daily practice

When I decide to start a drawing I routinely encounter hesitation, but once I begin making marks on the page that feeling gives way to an undeniable lift. I can compare that lift to the thrill I feel in a moment of awareness, on a hot summer day, when I am in the air, having decided to start my swim by jumping into the deep end of the pool. Once I'm in the air there is no turning back and I know things are going to change. People often ask me if I have a special time of day set aside to do my daily drawings and I tell them, "All day." If in the first practice you had any taste of the openness and joy that results from just allowing your hand to draw whatever comes up you will know why I draw every day. I started drawing regularly without any reason other than "it felt right," but there was a nagging sense that something inside was waiting to be discovered, and it took all my creative and analytical effort to uncover it.

I can point to February 22, 1999, as the day my drawing practice turned inward. Busy in my studio on West 35th Street in New York City, I did not know that I was only a month away from making my first big commercially successful artwork. *Color Panel v1.0* was a small program running on Apple's first color laptop, the Apple 280c Powerbook: The laptop was disassembled and the screen flipped around, and both were attached to a plastic housing that hung on the wall. The laptop ran custom software, turning on and off like an appliance, and it spent the day making art that evolved and varied continually. The piece wound up in three major museum collections within the year, launched an eight-year run of these so-called "art appliances," and helped establish the software art market. On that cold February day I was at the beginning of my journey, quietly working away in the studio and trying to sort out how I could transmit to viewers the excitement I got from making my drawings by using digital media.

I had a background in both programming and art. I had been working independently for about six years making drawings with software tools, and I had the vision that a computer could be taught to innovate like me. To move my work forward I saw two choices: I could try to develop a computer program, previously

unimagined, that would somehow innovate beyond its original set of instructions (i.e., be creative), or I could develop a deeper self-knowledge, an understanding of my own creative process and unspoken rules, and then simulate this internal process in code. Computer algorithms are limited compared to living creatures, which evolve and become more complex; I was seeking a kind of unpredictable but coherent emergent behavior, nothing less than the world's first autonomous creative artificial intelligence. I had high hopes! So that morning, sitting down at my desk as part of my job as an artist, I devised a research project. If I couldn't yet come up with a synthetic or mathematical way to generate creativity, I would try to do it with brute force, by building an expert system based on the rules I deduced from my own observed tendencies.

This was the plan: sit quietly with markers and paper, wait until I had an impulse to draw, and then follow that impulse. If I made, for example, a set of vertical lines and followed that up by crossing them with horizontal lines (as opposed to diagonal, or any other orientation for that matter), I would try to identify, as they were happening, the little decisions that I had made to draw that way. I hoped to discern my unspoken rules for drawing and turn them into code.

I like to say this research asked the wrong question but got the right answer. The project to find and code my own internal rules for drawing never led to the programming solution I had hoped for, but as it turned out, the way that I set up this research in self-observation—by making rules such as allowing anything to come up, observing my impulses, and looking into the source of each impulse—all worked together as a self-inquiry meditation. This kind of meditation is practiced in some spiritual traditions by asking oneself a question like, "Who am I?" In my case the question was, "What is the source of this decision?" And, as is often the case in self-inquiry meditation, there wasn't a direct answer, but the benefits of asking spread to all parts of my life.

Watching Your Hand

Using the same pencil and paper, begin this practice by consciously slowing yourself down. When you make marks, focus your attention on listening to your breathing and watch your hand as if it were a robot acting on its own. Observe with as little interference as possible. Note everywhere that hand-shaped creature crawling around the page. Take a minute now to try it out and after a short time have a look at the trail that the hand left.

Can you describe the marks as a mess of scribbles, or do they make geometric forms like rectangles and spirals? Are the marks tight and dense or broad and gestural? I'm also asking you to pay special attention to the *feelings* that arise while you are watching your hand draw, both positive and negative, both levity and resistance. Was there a moment or two where you felt free letting it happen, laughing to yourself like a kid again at the absurdity of the practice? There is freedom in that moment, and drawing daily will help you recognize and expand that freedom. Can you observe carefully enough to notice, after the letting go happens, what feeling eventually restricts it?

Now, equally aware of your thoughts, allow your hand the freedom to make big gestures that fill up the whole page. Let your hand draw over what was drawn before and make the biggest and smallest marks possible.

Draw like this for a short time. Occasionally start with a new piece of paper. Try not to bother yourself with what, if anything, is taking shape. Just watch.

Paper and tools

I haven't mentioned materials yet, and the truth is that media is really an individual choice, but I do have some pointers. Try not to choose materials that take a while to prepare or clean up. Save the elaborate media for more finished work or deliberate practices. At this point the practices are all about just doing, so stick with things that make it easy. Whatever pencils or paper you are comfortable or excited about using, please experiment with them, but remember that this work is all about getting into "flow," an easy mindless state where the hand is just working. So identify by practice the materials that interfere the least with your flow.

Picking a type of paper to draw on is like picking a spot to meditate. The paper is the quiet space where everything will happen, and it should be comfortable but not too elaborate. If you buy paper that is expensive or rare, you will hesitate to use it for fear of making a mistake or wasting money, and you'll be reluctant to get more paper quickly when supplies run low. It's best if these drawings have no commercial prospects so that there is no inkling of value attached to the activity. Newsprint, envelopes, or the backside of printed documents all work fine, and that way you can be really free to experiment, mess up, and discover.

In the early 1990s I had identified myself as a "pen-plotter" artist, using a machine to hold a pen and make my art. I chose beautiful sheets of 100 percent rag printmaking paper and I called these drawings my "real" work. On the side, however, I began drawing by hand on the leftover scraps from the edges of these larger drawings, a kind of adaptive reuse, and since the paper was free, I could do whatever I wanted. Many of the improvised shapes that emerged in those drawings still appear in my art today.

Now my surface of choice is a paper called multimedia art board. It is an archival card stock stiffened with resin that slightly repels water and provides an extended working time. I cut large sheets into 5"×6" rectangles that look like large index cards. The size works well because I can cover the length of the card with simple gestures, making it easy to work quickly and not use much gouache. Most daily drawings take anywhere from a few minutes to a couple of hours to complete.

If I make a few marks and meet resistance, I'm happy to put the card aside and grab another one. The cards accumulate on my desk and many get reworked. I prefer cards and scraps of paper to pages bound in sketchbooks because some time later in the process, when I am reviewing and sorting the drawings, I can lay all the cards out in a grid on the table. I like the card stock because it is easy to sort and flip through stacks of them. Over the years I have made several thousands of these cards.

What markers, pencils, or paints are the best? Use what you like. Make discoveries. Go to an art store and have fun—choose things that attract you. I have used technical pens, colored pencils, gouaches, watercolors, charcoal, and inktense pencils (compressed pigment that draws like a pencil but can be activated with a wet brush—fun!).

When I am ready to do my daily drawing, I pick up a pencil and start. Since I make cards and often stack them, I am also careful about choosing materials that don't rub off easily. These days I like to use a 9H pencil—a very hard graphite that doesn't smear easily. I like gouache because it can be opaque out of the tube and thinned to transparent with water. I like to draw when I travel and for those times I often work with a red lead pencil, as the red leads are very waxy and durable. I also like to think that the red is a symbol for a nonordinary drawing—the kind I would make in an airplane or on a train.

Marking practice

More important than the media you choose is establishing a regular practice of making marks on paper. My idea to name this style of drawing "marking practice" came to me fairly recently when I was introduced to a style of Insight Meditation commonly called "noting." Put very simply, when I engage in noting, I try to pay close attention to the stream of mental phenomena rising into my conscious awareness, isolating every sensation that I smell, hear, taste, touch, see, or think. The "noting" part is when I identify each phenomenon to myself—"smelling,"

"hearing," "feeling," etc.—either quietly or sometimes aloud. Every time I am aware of a sensation, I make a note of it. I might note "hearing" when I hear a bird or a car, or I might note "feeling" when the chair I am sitting on feels hard, or "feeling awake" if I feel energetic. Noting can be focused on different levels, calling attention to different aspects of experience, such as body sensations, emotions or feelings, thoughts and mental activity, or even awareness itself.

Noting can also be practiced in groups, each person taking a turn noting and saying aloud what phenomenon is present for them at that moment. Very often one person's note will influence where the whole group's attention moves. It was during a group noting session, when the collective attention kept getting directed to a loud and obvious noise nearby, that I first noticed a similarity between the feedback loop we were centering around the noise and the way my own attention gets pulled over and over into what I am seeing as a drawing develops. Being attentive to this sensory feedback during drawing increases my absorption in the drawing.

Marking Practice

If you've never tried the practice of noting—slowing your mind to the point that you pay attention to everything that crosses your awareness and note the attendant sensations—spend a minute or two with it, just becoming more aware of what is present for you in each moment and identifying the sensation: Hearing. Seeing. Feeling. Impatient thought.

After a few minutes of noting, take out a clean sheet of scrap paper and enjoy a deep breath. For this marking practice, you will start by continuing to note whatever sensations arise, but instead of identifying the sensation with a word in your mind, let the pencil in your hand make a mark on the page. The mark should be completely random, and no two marks need be the same. Don't make up a shape to be a symbol for the sensation you note; bypass that level of mental noting and let your hand respond. For example, if you note hearing the sound of the wind in the trees or the running of the air conditioning, direct the impulse from your mind to your hand, bypassing the naming and observing what appears on the page. Every time you note "hearing," the mark produced will be somewhat different.

Let your hand move freely. Allow forms to arise without examining or reflecting on what you are drawing. Allow a hodgepodge of lines to form if their uniqueness and combinations will more clearly reflect the complexity of the sensation. A sound is not just a sound—it carries information about where it was created in relation to your body and the materials that collided. Also, a sound can evoke emotional reactions; for instance, the grinding of a garbage truck may carry irritation or relief; the sound of rain can be soothing or anxiety-causing. Marking freely and unconsciously combines many layers of these emotional and physical overtones. What we are interested in discovering are the subtle differences in sensations that are not captured by a small set of words but might appear in gestures. Later, it will be interesting to identify the kinds of persistent and similar symbols that arise naturally from the process.

Mark for a few minutes and then stop. Is there structure or is it a total mess? Despite your best efforts not to edit what you were drawing and to simply redirect the sensations to the hand, notice if there are any forms you can recognize. If you step away and come back to the marks freshly, what feelings arise? Are you cast back into the state of mind when you drew the marks or does a new story suggest itself?

The answer in the question

Now that you've had some experiences making marks on paper, I want to return to the programmer's question, which sat in the back of my mind for many years. He asked, "If I want to make a good drawing, how do I go about it?" What answer did I finally discover that was contained in his question?

First, after trying for so long to program computers to make drawings autonomously, I noticed one key factor that distinguished me from the machine: I *wanted* to make a good drawing. The first step in making a good drawing is recognizing and giving voice to the desire to create. The creative urge is the engine that will drive the great effort it takes to pursue art over the long term, and understanding the nature of this desire will be critical in staying motivated long enough to develop good work.

But wanting a good drawing and even making the effort are not enough. The rest of the answer is contained in the programmer's goal. What makes a drawing good? It would be impossible to list all the qualities of a good drawing, and in any case the list would be different for each of us and each artwork we liked. Luckily, we don't need a precise definition. We understand how to proceed with our creative work by developing our intuition and learning to pay attention to what we value and respond to.

In the moment the programmer voiced the words "good drawing," he probably had an ideal image in his mind. What was that ideal? Could he put it into words? Could he even see it? It might have been something as concrete as a drawing by Rembrandt or Picasso he saw in a museum, or he may only have been pointing to an abstract feeling he would certainly have in the presence of a "good" creative work. This imagined good drawing is really just a signpost on the road of creative practice—a guide, a standard against which we judge our work. Getting to know what exactly we point to when we point to a successful artwork is the seed of sophisticated taste and a refined ability to discern good creative work from bad.

That could be the whole book. I could stop right there and let you loose, like a Zen master pointing my robed arm to the studio and saying, "Go draw," and

allowing experience to do the teaching. Finding a path in art is very similar to finding a contemplative path. You have to want to do it, possibly for some unknown or ineffable reason, or for no reason other than you feel as though you must. Curiosity is the guide that opens whole new worlds. For the better part of my wanderings through the creative process, the stars that guided me were my desire to make something beautiful and my openness to discovery.

To the question, "If I want to make a good drawing, how do I go about it?" I say, yes, go about it exactly that way: use your desire to catalyze a regular creative practice and use discernment to judge what is good. Then you'll find yourself well along the path.

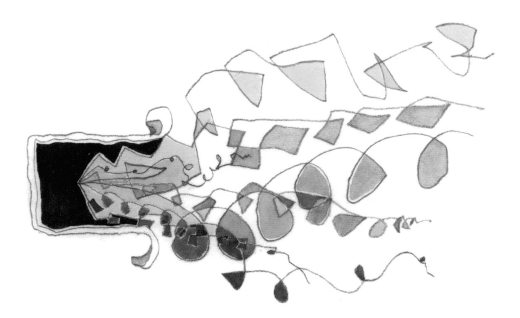

Breaking Free
02.06.2013

2
REALISTIC DRAWING

When I ask new students what kinds of drawings they like to make, the response I hear most often is, "I can't draw!" As I hand out pencil and paper, I say reassuringly, "It's not true." But I feel the stiff resistance, the tension that fills the air when I ask them to draw. What's hard about it? Drawing is fun. Why don't we draw more? Has realistic rendering become the sole measure of a successful drawing? Are drawings not good if they don't look exactly *like* something?

Even after decades as a successful artist, I still get stuck on *what* to draw. If I choose an object, fear becomes a goblin holding me back—fear of failure, of not measuring up, or of just being banal, but mostly fear of my drawing looking weird. Drawing makes me vulnerable. Doubt has a role in holding back the sheer joy of expression: ee feel uncertain of our drawing's value, we worry about the cost of time and materials, or we have doubts about how much effort will be required. However, the strongest initial resistance to drawing, for me, comes from the inner critic—the judgmental voice in my head. I imagine I hear people judging my work, devaluing my efforts, or comparing my sketch unfavorably to someone else's finished work, and I just don't want to face that!

The great twentieth-century painter Philip Guston, known to work long hours in the studio, once repeated something the composer and artist John Cage had told him: "When you start working, everybody is in your studio—the past, your friends, your enemies, the art world, and above all, your own ideas—all are there. But as you continue painting, they start leaving, one by one, and you are left completely alone. Then, if you are lucky, even you leave."[1] Guston, and Cage before him, were articulating the reality that dealing with internal resistance, with the inner critic, is an integral part of an ongoing creative practice, not something that

<hr/>

1 Musa Mayer, *Night Studio: A Memoir of Philip Guston*, (Cambridge: De Capo Press, 1997), 171-172

Spice Bush
09.08.2011

is permanently solved. In this chapter we set the course toward a place so far past inner resistance and so deep in the flow of drawing that even *we* leave.

Finding myself in unusual circumstances

I began the journey by train from London in late May—I was crossing France en route to a summer art program in Florence, Italy. I had just finished my sophomore year at Brown University, where I divided my studies between geology and art. It was an in-between time for me—my interest in being a scientist was wavering, and I didn't know that being a full-time artist was even possible. Meanwhile, my youthful enthusiasm for fun was distracting me from my academic concerns, and Europe's incredible historical and cultural surroundings were opening my eyes to the world. With each mile traveled, my identity was dissolving and being remade all at once. I was searching in art for what I hadn't yet found in scientific materialism, trying to discover the nature of that energy inside me that needed voice, recognition, and orientation. I was traveling to find out for myself what was real.

My Eurail pass and tuition for six weeks at an American-run art school were paid out of my own pocket, with money I'd saved from a part-time job selling cameras in a Kmart in central Louisiana. I fit the stereotype of a traveling student: saving money by sleeping on overnight trains instead of staying in hotels, carrying a backpack, eating gyros, drinking cheap wine, smoking, and spending my days in art museums and parks. It was a summer of discovery, a rare opportunity, and I was aware of my freedom.

Four days before starting my figure drawing classes in one of the world's greatest art cities, as I stumbled into an unfamiliar train station café with hours to wait for the train to Florence and ordered a strong cup of espresso, I felt empty, truly empty. So much time looking at art was opening new possibilities in my life, and my image of myself began to shift. Solo travel, solo meals, and solo nights intensified the introspection that arises on any journey. I traveled through several cities but felt stillness, a calm in the storm. I didn't know then that this emptiness is

extremely fertile ground for creativity, but to occupy my time waiting for the train I felt prompted to draw. I opened my backpack, grabbed my spiral sketchbook, looked up, and found myself.

There I was, sitting across from my reflection in the mirrored wall, a disheveled, unshaven, twenty-year-old, self-important, tense, American tourist, staring back, the menu painted on my reflected forehead. I was buzzing on the caffeine, I had nothing to do, and I was happy, excited, and wary, a high-strung vessel. I needed a way to record that unique harmony of physical, emotional, and intellectual states, to savor the youth, the energy, the naiveté, and the longing. I was so available, so open in that moment, seeking a way to be engaged with the world, to *do* something rather than watch, to be a participant and not a tourist watching the surrounding scene, to contribute creatively. I wanted to connect with and express in concrete form the stream of creative energy I felt pulsing through me.

Travel stress and sheer, hopeless boredom soon gave way to inner peace as I looked up at my face in the mirror, at the distance between my eyes, at the shape of my left eye, and at how my left eye tucked into the side of my nose, at the shape of the shadow created between nose and sunken eye. My hand began moving, outlining on paper the shape of that shadow.

Time evaporated.

I produced a cartoon drawing, but the caricature made me laugh and shocked me, too—making something, even a silly sketch on paper, felt significant. The image was revealing: My eyes were surrounded with crazy, wavy lines. There was harmony in the situation, sitting in a café, the action of waiters and customers, the rhythm of the pencil, and my intention to know myself better. In the euphoric lift that followed, I noted that I no longer felt like I was "missing something" on my journey: there were no museums I needed to see or sites on a list I still had to visit. I sat in that café in that moment, and my drawing proved the fact of my existence to my judgmental self. I was productive—something had happened. I saw the first glimmer of how creative practice can be a doubly fulfilling meditative escape, because both the process and the product have value.

What happened in that moment when I started to sketch? What triggered my hand and made the drawing flow? Why was I able to initiate a drawing of that scene when I found it so hard to begin a drawing in art class when I was "supposed to"? One reason I was able to get into the flow of the drawing was that I had the time—nowhere to be and nothing to do. A second, larger reason was that I was engaged with my subject, with a kind of resonant sympathy and love. Surprisingly, the real trigger was my reflection in the mirror.

Autumn Kissing Summer Farewell
09.23.2011

Picking an Object to Draw

Before picking up the pencil again, let's follow some simple steps to choose an appropriate subject to draw, one that you are excited about drawing. Take your time and enjoy this process; your choice is as important as the lines you make, and the reasons for your choice will determine how connected you are to the final drawing. The process is not about locating the most unique or ironic subject but simply being able to identify how you feel about what you see.

Do this practice outdoors, on your street, in a yard, a garden, or a park nearby, hopefully a beautiful place, green and in bloom; but even if the place you visit is surrounded by brick or concrete, even in a frozen or barren landscape, you will find naturally occurring details that will fascinate you. This is a quiet activity. Move slowly, breathe deeply, and focus your attention on your eyes, noticing where they move. Probably they are darting around—that's good. Take it all in as you wander around in an unhurried way, widening your attention to the sur- roundings. Turn your head and scan the environment; go where you like while waiting patiently for the moment that something catches your attention. As the photographer Minor White says about choosing what to work with: "When you approach it you will feel resonance, a sense of recognition. If, when you move away, the resonance fades, or if it gets stronger as you approach, you'll know you have found your subject."

Choosing an object to draw should be a practice in itself, a way to wake up to the world, but to me it has always been a chore. Many times I have avoided practicing realistic rendering by thinking there's nothing I'm interested in drawing or that I don't want a picture of some specific thing. When I want to render, after procrastinating for a while, the words of my drawing teacher come back to mind. The painter Georgia Marsh is gifted at rendering and even more at reading visual works. Even now, years after graduate school, I follow her work and seek out her opinion when showing mine. About ten years ago I was still hesitant to commit to rendering, so as we chatted over coffee at a café in Chelsea in New York City

I tried to convince her that I didn't render because I didn't find any object interesting enough. She cut off my whining midsentence by lifting her finger to the coffee cup on the table, moving her finger slowly enough between the rim and the handle that I had to focus my attention on the gap, and said, "Look at the distance here and see the tension that's created. Can you draw that space?" I realized I was compelled by what she was pointing out. I was too attached to the label "cup," and it was keeping me from really slowing down and looking at what was there. Focus generates interest.

The object is of secondary importance to how I *see* the object. The poet William Blake wrote that it is possible to see the world in a grain of sand, reminding us that concentrated looking is the way to get past labels and our preconceived ideas of what interests us. Looking slowly and in detail, the boring coffee cup on the table gives way to interlocked abstract shapes, energetic textures, ranges of colors, spaces in between things, sharp edges, and soft shadows. This way of seeing objects turns any item into an interesting subject. Focusing my attention is how I begin to see. Realistic rendering is a practice to develop this concentration.

Pick up your pencil and sit comfortably gazing at the subject you have chosen, practicing, as Minor White suggests, being "still with yourself until the object of your attention affirms your presence."

I can offer several reasons in addition to caffeine and travel stress why my reflection in the mirror of that French train station café shifted my perception far enough outside the ordinary to trigger me into drawing. A mirror is not a perfect reflection, so when I glanced up, my eyes darted about trying to reconcile what was part of the room and what was the reflection. While my eyes were busy, my inner commentary settled down. The text of the menu written on the mirror broke up the continuity of the scene. My depth of field, shifting focus between menu and room, formed a window for me to peer through, pushing back my point of view and making me feel more like an observer than a participant in the scene. As my eyes scanned the room, the mirrors were disorienting discontinuities and I saw myself from many angles sitting in a strange new place.

Visual textures cause physical sensations in my eyes and sometimes, almost synthetically, accompanying emotional sensations. The mirror world was one layer removed, like watching a video on a screen, in part because the light reaching my eyes was not actually being absorbed and reflected from a real texture but only from a smooth sheet of glass. Glass feels very different to my eyes and plays differently in my head.

Gazing at the reflected café scene—the table in front of me, the coat hooks above the banquette, the bottles behind the bar—I saw how the entire depth of the world could be flattened onto the surface of a mirror. I studied my coffee cup sitting on its saucer. I knew the rim of the cup was a circle but if I raised my finger to the mirror and traced around it in the reflection, the smear that my finger left was not a circle but an elegantly elongated ellipse. Seen as just a smear on glass, the shape was freed from the label "cup." Beyond the well-defined objects on the table, I saw that shadows falling on multiple plates, smoke curling past windows, and color patches from neon signs could all be flattened into outlines on the surface of the mirror. When I can pay attention to what my eyes are reporting, with no labels or preconceptions about the subject of my drawing, and use my hand to trace the shapes from eye to paper, the renderings resemble what I see most closely, and my pencil lines on paper become a mirror of the world.

Attentive Looking

This practice is a more specific version of the noting practice described in Chapter One. In this case, we narrow our focus on the senses and only pay attention to our sight—training ourselves to notice the perceptual shifts constantly happening between our eyes and brain. The key to this practice is setting up and following the correct view.

For this practice you will need a mirror or digital camera. Choose two objects about the same size and place them on a surface a short distance away from you in a position that makes it easy to glance up and see both things without moving your head. Arrange the objects so that one partially blocks the other from your line of sight. When I first learned to draw, I mistakenly drew the outlines of objects as whole shapes, ignoring any objects that might be in front of them because I "knew" what the blocked part of the object looked like. My mind happily filled in the gaps. By doing this, I was missing the wholeness of the scene, and my drawing reflected that.

Hold up the mirror to see your objects, or snap an image with the camera. Touch the glass surface of the mirror, or the screenshot on the camera, and begin to run your finger slowly along the outline of the far object. Pay close attention when you reach the boundary between the two objects and the shape of the line your finger follows. That line is not part of the back shape; it is defined by the front shape. The outline you are tracing will not be easily labeled; for example, it will not be a bottle shape or a cup shape, but instead, the outline of the far object will be a sort of familiar shape that looks like someone has taken a front-shape bite out of it. That new combined shape is the one we are interested in seeing, either on paper or screen: the new flat combined shape that has no name.

If your subject is familiar, like a bottle or a leaf, you may find as you trace the outline that your mind struggles to believe your finger. I often smile to myself when my mind finally gives up outlining "coffee mug" and gives in to following

what my eyes are reporting. This shift in perception creates such a qualitative difference in the drawn line that it is easy to tell where a sketch has been done from the eyes and where it has been imagined or abstracted by the mind during drawing.

While you are paying attention to the boundary between objects, try this trick. Flip your vision back and forth between knowing the two objects sitting on the table and seeing only the shapes presented to our eyes as flat outlines. Note how powerful our perception is, that we can shift it this way. See if you feel differently about your sight or the world you are seeing when the shift takes place. Flattening the scene in this way is helpful when sketching outlines and contours.

Extending the gaze with a mirror

For years, computers and screens were integral parts of the artworks I made. The screens displaying my custom graphics software were presented in art galleries and museums as endlessly changing, never repeating paintings. My art dealer, Sandra Gering, put the prototype of *Color Panel v1.0* on display in her office immediately after seeing it in my studio and the Guggenheim Museum acquired the first of the edition two weeks later. This began a fourteen-year run of experimental work exploring the possibilities offered by software-based painting. I varied not only the code but also the way the screen was hung on the wall and what surrounded it. I searched for ways to physically alter the computer screen, because the screen's glass surface reflects an even shininess, and one of the great joys of painting—some would say the essence of painting—is how the eye moves across the surface and is enchanted by the beautiful variations of texture and color. I wanted very much for the screen's physical presentation to be this nuanced. In some experiments, I overlaid the screen with laser cut Plexiglas masks to alter how the eye crossed the surface and changed the colors of the graphics beneath. I had experimented with scratching or painting on the glass as a possible way to vary texture but if the screen ever burned out, as they do more often than we'd like, any direct marks would be impossible to transfer to a new screen. In 2007, I got the idea to hide the screen, to turn it away from direct view, so that it could only be seen as a reflection in a mirror.

One day, while trying to come up with an engineering plan for these new reflected screens, I went out for a walk along the road to clear my head. I was trying to visualize how the screen and mirrors would work in relation to the viewer. I imagined someone entering the gallery and, upon seeing a large cabinet hanging on the wall, they would first pay attention to the colored patterns on the surface of the material. Then they might notice that part of the surface was a window, and maybe the motion inside would catch their eye, drawing them in for a closer look to see the inner activity of the object reflected outward. As I followed these thoughts I saw a parallel between this geometry and how the images in my mind were only

reconstructions of the light that was brought in through my eyes. This brought on a deep sense of the fluidity of the world, that the world I saw "right before my eyes" was only created in my mind's eye. During this simple shift of focus, from outside to inside, background awareness sprang into the foreground—a very moving experience.

Unless you are a regular meditator, you probably don't experience the world-shifting moment I'm describing above when you read the words "awareness sprang into the foreground." This is a good example of a place where it will help to do the following practice and not just read the words. Resting in the spaciousness that surrounds thought, the negative space of yourself, is awareness—pure observation of the scene without thinking about it—but you won't understand it until you try.

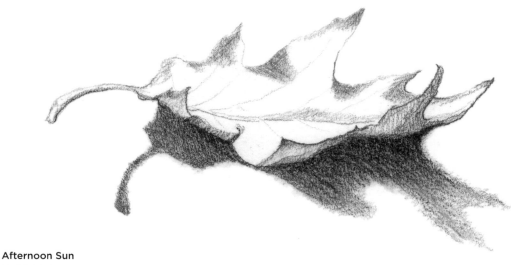

Afternoon Sun
10.30.2010

Noticing Awareness

Start by focusing on a tiny portion of your chosen subject: maybe the edge of a leaf, the place where the handle joins the mug, a dip in the rock.

Take a deep breath, exhale, and then slowly broaden the focus of your attention until it is as wide as possible by imagining you are a video camera backing up—still looking at the subject but aware of as much as possible in the field of view. Try to take in all of what you see at once by pretending that the whole field is just an image being reflected from a mirror, as though you are standing in a huge mirrored hemisphere. Everything is a reflection. As the field of view starts to recede and look like a separate place—like when viewed in a mirror—awareness will come to the foreground. It's not hard to make this happen, but don't force it; allow it to happen and be sensitive to what is surrounding you. You may find you can cause this shift by seeing each object as its outline, as in the previous practice, and noticing how the flat scene fits together like a jigsaw puzzle. It may also be helpful when practicing awareness to have a pocket mirror handy and gaze at the scene in the mirror—discovering a separate world through the looking glass.

Practice this shift for a few minutes. It won't take long—just look and don't try too hard, relax your eyes, shift back and forth from depth to flat view. Also, though, notice that when you are not trying to flatten the view, being in the scene seems "normal," and when you flatten the view the feeling shifts to being an observer of the scene. Give that observer some space and see how long you can view a flattened scene as observer. Sit for a few moments in this awareness, looking out through the organs of sight but knowing what you see is all part of what is passing through the brain.

Deliberately deconstructing the eye-brain-mind system fascinated me, but I also found something unsettling when I was finally able to separate the sensations of eye and mind (by using my mind!): it feels like I'm spying on my own thoughts. But since then I have found this practice of separating visual input from its mental representation to be a reliable method of shifting background awareness to the foreground and improving my concentration and rendering skills.

When I want to work with this technique, I visualize how my eyes work and I trace the path of the light as it enters my eyes. Before beginning to draw, I sit for a minute with the idea that the light rays entering my eyes are not what illuminate the image in my brain. I pay attention to the physical apparatus of my eyes, how they feel in my head, by moving them side-to-side, and blinking. The light they sense—in the visible wavelengths, in the light allowing me to see this page right now—can be nicely pictured as multiple streams of energy, varying in quantity and color, carrying information about their source and the objects they have touched before reaching me. As a human being, my body is constantly bombarded by light from all sides, some making my skin feel warm and some entering my eyes. The light that enters my eyes is registered as colors and brightness by the rod and cone cells of my retina. The retina converts the photons to electrical signals, and those pulses travel along the optic nerve to be made into images by the visual cortex. Some parts of those mental images are isolated and given names: car, food, chair, Mom.

My old-school photographer friends still claim that images captured on film are a more direct transmission of the world than those processed through digital cameras and computers because the photosensitive surfaces capture the energy of the incoming photons instead of converting them into an electrical signal. Audiophiles make a similar claim about analog recording devices bringing listeners closer to the vibrations of the live performance than digital recordings. But the individual light ray that enters my eye is not the energy that makes the picture in my brain—not even close. The photon is converted by the eye to an electrical nerve impulse, and further processing takes place on the way to the visual cortex.

Information is overlaid with meta-information: emotions, memories, biases, etc. I have found that thinking about such details of the image construction process can be a powerful place to focus when taking apart a scene for drawing.

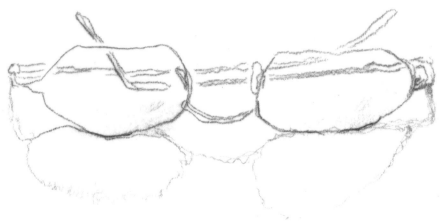

Where are my glasses?
6.20.2013

Marking from the Sense of Sight

Gaze at your subject with attention on your sense of sight. What do you notice? Is there a difference between seeing a thing and noting that you are seeing? Glance around your space and see what catches your eye. Can you observe the arising of memories or emotions that familiar objects trigger? Do you feel differently about your subject as time passes? Drawing with self-observation is a kind of mind training. Seeing the subject as if it were a reflection in a mirror is a type of concentration practice that will be very helpful when we turn inward.

While you are in this attentive state, make marks freely on the page when you note the sense of sight. Observe the marks as they appear on the page as if they were showing up in a video. Who's watching?

LOOKING vs SEEING

Reflections of Florence

When the train I was waiting for at the café finally arrived, I packed up my sketch-pad with the feeling that something in my perception of the world had shifted. I'd just experienced a way to move my attention that allowed me to flatten the scene in front of me: my mirror eyes. Learning to shift attention was my key to learning to render. I boarded the train and spent that night leaning against a window that half reflected the dark interior of the car and half let in light from the small towns passing by. I woke up in Florence to my first taste of the incredible Tuscan sunshine.

I still have vivid memories thirty-two years later of the summer I lived in Florence. I can see the impossibly large and heavy wooden portal of the school's entrance, as well as the small, useable door cut into it that opened into a cool stone corridor from a nondescript facade on Via de' Ginori and led to a large studio, which was scattered with easels and a small platform in the center for models. The smell of linseed oil, a skylight, a roof terrace for smoking cheap cigarettes, a tiny *tabacchaio* on the corner of the block that sold strong espresso, and a pizza joint where you sat on stools that stuck out on the sidewalk. They made a pie with such a thin crust and so sweet a tomato sauce that it felt decadent—yet it cost so little that all the students ate there.

The street, all made of stone, and each facade different, narrow, and charming by my American standards, was energetic with cars moving slowly through packs of scooters; the sidewalks were crowded with well-dressed Italians and shoddily dressed tourists. Across from the school entrance was a rollup door that was seldom open, maybe for an hour in the morning, and sometimes after dinner, never when I expected or wanted it to be open—when the door was up there was no storefront, no glass windows or entry door. The wall merely opened into a twelve-foot-wide by twenty-foot-deep box lined with white, red, and green tiles. The space was mostly occupied by an enormous refrigerated display case, fogged up with moisture, white enamel chipped and rusted, glass curved up to a flat counter on which sat an old weight-driven scale. I only decided to step in the first time because the door was up, and I couldn't believe it was really a store. The scarce inventory of the case—aside

from a few squarish, complicated meats and some large wedges of hard, yellowish cheese—was made up of enormous tubs of big green olives.

I pointed. The man said, "Sicilian . . . *mezzo litro*?" holding up a slightly big container. I nodded and pulled out my thousands of *lire*. My impulse buy had happened so fast that I had no time to remember that I had never eaten a green olive. Would I like these? Outside the shop I bit into one and, *oh my*, they were so fresh! A thick meaty texture gave way to rich oily flavor that felt nourishing—sharp smell, saltiness, relief, joy, discovery, a new favorite, empowerment, and love all rippled

Dreaming
11.8.2013

Beauty is a dream,
Body is a dream,
Being is a dream.

through my system. These olives and a fresh piece of bread served as my lunch on many school days that followed. Those unforgettable fruits imprinted me with a tacit knowledge that things are better when sampled closer to their source. I have never felt the same about food since.

All summer in Florence, a capital city of art and art history, I felt like I was nourished directly from the source of European culture. So much legendary art is contained in so small an area that there is actually a name for the pronounced dizzying effect brought on from indulging in too many Florentine masterpieces: Stendhal Syndrome. After one week, I got it, realizing that I was living in the same city, walking the same streets, as the great figures of the Italian Renaissance—towering artists like Giotto, Brunelleschi, Donatello, Michelangelo, and Leonardo da Vinci. How lucky that I could go on a short walk from school to the Uffizi, to take in, for example, Botticelli's *Venus*, then wander back to figure drawing class.

On school days, my fellow students and I would gather in the studio with big pads and pencils. A model would undress, then do a few short warm-up poses followed by longer poses, short breaks, coffee, and more poses. And so, sketch by sketch, would go the afternoon. My renderings were disproportionate and flat. I struggled to represent smooth curves, long hair, and a muscular stomach. When we were done, everyone would walk around to look at each other's work and I don't know who felt more naked on those days, the model or me—my lines all exposed on the page to the judgmental eyes of teachers and students, my effort as obvious as my shortcomings, watched over by the ghosts of the genius artists who had lived there before. Figure drawing was teaching me both to see and to know myself better. Each tentative line was a mirror.

Simple Rendering

The next few practices are basic drawing instructions, the kind you'd get in a beginning still-life class. If you have never drawn from life, these practices will start you off right. Don't try too hard or get too attached to the results—coordination and muscles need time to build up, and estimating correct proportions comes with experience. Work quickly and on inexpensive paper that you don't mind tearing up or throwing away. If you've been drawing long enough to be familiar with these practices, I invite you to repeat them, but with your attention very wide and mindfully allowing the sketch to develop automatically and observing your instincts.

First, let's return to the two objects we arranged on a table in Practice Seven, with one partially blocking our view of the other. Once again use your eyes to flatten the field and isolate the shape of the far object. Pay special attention to the line where the objects overlap. This time let your hand outline the shape on paper. Try to look only at the subject and not at your hand. You should see a hybrid shape made of the partial outline of the far object with what looks like a cutout in the shape of the near object. Try a few small sketches from various angles. Does the missing space suggest anything to you?

Next, place a few objects of similar heights but different shapes in a row on a table, then put a long object like a yardstick across the top. Start by flattening the view, as though looking in a mirror or camera, and seeing the spaces between the objects and under the yardstick as a two-dimensional closed shape. Now draw just the in-between shapes, not the objects, trying to also be aware of the distance between the shapes relative to their widths. The shapes of the objects should automatically pop out from the negative spaces (i.e. the spaces around and between objects).

I know you can imagine what it would be like to do this; I am imagining what it will look like as I write. But what I have to *say* about drawing makes no difference. You won't benefit from this discussion unless at some point you stop

reading and start sketching. Doing a few quick shapes will build up your capacity to see the space in between. After it seems more natural, look up and around the room, trying to see only the spaces between things as shapes. Notice that when seen as a flattened space, nothing in the room appears separate from anything else.

Gravity Test
05.07.2013

The dominant view is established

Il Duomo di Firenze, the main cathedral of the city, was just around the corner from the school. I passed it daily while walking to and from classes, and for most of my stay I never thought to visit it since I thought I was not interested in churches. Little did I know how neatly the history made on this spot over five hundred years before would align with my interests. Luckily the school's art historian insisted I join her for a tour and lecture of the cathedral; she said it was "not to be missed," and she was right. She told us a story of genius, invention, and discovery, having us stand just inside the cathedral door, facing outward toward the Baptistery of St. John across the way, standing just far enough inside the church so the doorframe enclosed the view, on the exact spot where Filippo Brunelleschi, the famous architect of the cathedral's enormous brick dome, a dome I climbed in awe during the same tour, stood painting. From there he painted the Baptistry, making the first painting with linear perspective since Roman times, after rediscovering the art of constructing an image with a single vanishing point and horizon line.

Standing there on that hot summer morning and hearing Brunelleschi's life story while touring the cathedral, I got more than facts. I began to sense what life was like in the Italian Renaissance, a time when paintings began to have identities separate from religious icons, becoming analytical and technical practices, and eventually autonomous art objects. The Renaissance was a time when rendering space became mechanized. Brunelleschi made his painting of the Baptistery to prove a point about the accuracy of his measured painting technique. In order to demonstrate how his image in perspective looked exactly like the actual scene, he arranged a little demonstration. First he painted the Baptistery in perfect one-point perspective on a panel. He then drilled a hole through the vanishing point of the painting just big enough to peep through. As people stood on the very spot in the cathedral where he had made the painting, they looked through the hole in the back of the painted panel toward the Baptistery. Or was it the Baptistery? Brunelleschi also had with him a mirrored panel that could be raised to reflect

his painting back through the hole to the viewer. Peering through the hole in the panel, the viewer might be seeing either the real Baptistery or the mirror reflecting the painting they were holding. According to the story, the views with and without the mirror were indistinguishable—Brunelleschi's painting technique was proven to be as true as a mirror. For an audience accustomed to seeing only paintings of flattened spaces, the advanced technology of perspectival depth seemed like magic.

Brunelleschi's demonstration set the dominant approach for European painting, initiating an enormous shift in how painters viewed space by literally creating a new perspective and shifting mind-sets from religious to architectural painting space, not only opening many new artistic possibilities but also setting the stage for a type of codified thinking and problem-solving that would seed the growth of modern science and technology.

How important was the rediscovery of perspective? In 1999 the *New York Times*'s Michael Kimmelman named Brunelleschi's panels "the artwork of the millennium," saying that with a simple trick he had proved that art could mirror life. Correct perspective became the hegemonic ideology for all of the ensuing drawing and painting, the de facto measurement of correctness. Today's 3-D computer modeling and manufacturing systems rely on the same view seen in Brunelleschi's mirror.

Try Perspective

Find a large book on your shelf or a shipping box you haven't yet recycled and place it in front of you. Begin to draw by making well-defined lines for each of the box's edges. Don't just draw a cube in the mechanical way you learned as a kid but take some time to flatten the field in your mind. Look at this particular boxy mass and its odd polygonal flattened shape. Follow each line and notice how the parallel sides seem to point backward as they move away from you. As you put down the eight or ten edges you see, notice your inner space. Is the mind creating what it knows a box looks like, or are you letting your eyes guide your hand to define this odd shape? Are you able to allow the mental chattering to quiet down as you transition into sketching, or are you busy judging the correctness of the angles? Can you both draw and self-observe simultaneously? What does it feel like?

How important is view?

The Buddha taught that establishing the correct view is essential. "Right view" is often presented as the first step in the Eightfold Path because the way we see the world informs our thinking, our goals, and how we treat others. Having the right view means having a deep understanding of the way things are, a clear view of reality. How interesting that linear perspective literally set the view, both visually and conceptually, for the next four hundred years of not only Western art but of Western thought!

What kind of view is linear perspective? Perspective gave power to a mind-set, an expectation, and a way of seeing the world that became very hard to argue against. A rigid preference for correct proportions pushed out more subjective ways of rendering. It wasn't until Impressionism gained prominence in the 1800s that perspective's hold on European painting loosened. That was in part because photography had by then grabbed the reins of objective rendering, further distancing and objectifying the world outside and apart from ourselves. From the distancing influence of perspective space, we seem to naturally assume that an artist is separate from the world being rendered, that the job of an artist is to faithfully record what is "out there," and that there is a single correct translation of what we perceive.

As depth became codified in painting, mechanized with the camera, and now automated in three-dimensional computer modeling, the one-point perspective has slowly become the "conventional" view. But if I adhere blindly, either by choice or instrumentation, to a set of rules for image construction, how much is my space for individual expression limited? Is it any wonder the informational world can seem so impersonal? Can you see how opening up to the simple act of looking and seeing, trying through the eccentricities of our own perceptual and physical system to render the world and see from our own perspective—colored by our own histories and emotional overlays, our own choices of subject—can bring incredible freshness to the process? Is it any wonder that marks on paper, marks that may or may not resemble the world, marks made from our own eyes, through our brains, and sent to our hands, seem so alive and personal?

Working Inward

Find an object from the natural world, something you respond to, and sit with it as the object of your attention. Flattening your view, look at the outline, and then narrow your field. See what portion of the object's interior attracts you and isolate the outline of this portion. Continue to descend in scale, finding smaller, more interesting shapes inside of shapes. You may find the shapes in your object are echoed like fractals, that each step smaller has a similar pattern, like the twigs on a branch filling space in the same way as the larger branches they're attached to, and the same as the relationship of branches to trunk, or the veins of the leaves with smaller and smaller veins in between.

At some point in this descent, your mind may contract in fear. How will you ever draw all these details? Don't worry, you won't. My strategy in dealing with overwhelming detail is first to generalize and to use shorthand, to find a less detailed scale where I am comfortable. Uncovering great complexity in a subject you view closely can be intimidating, trying to draw all that detail overwhelming, but try anyway, by starting with a section of small shapes. I find it interesting that at the closest scales, when I am settled into the drawing, I lose sight of the object. The label of what I am drawing is gone and the shapes that make up my realistic drawing appear very abstract. I realize that somewhere deep inside, realism is always abstracted.

Leaving Florence

As time went on and I gained confidence in drawing the figure, I started to expand my focus, taking in more and more of the field, paying attention to the edges of the page, the position of the figure on the page, the negative space surrounding it, where the frame cut objects off, and what shapes were left. I was moving from sketches to completed drawings but something else was happening. As the drawings progressed there came a point when looking at the world decreased and looking at the page became primary. Instead of being a picture of a subject, the paper became a thing in itself, an object with its own reality and history. The decisions about marks divided between fidelity to the model and what was best for the finished work on paper, marking the point where the realistic rendering began to deviate from reality. While I learned to mirror the world, I was also learning to bend the mirror.

Everything changes. It was soon time to go back to college. I left Florence having tried my best to learn to render the human figure from the traditional perspectival point of view that was begun in that city five hundred years before. I drew honestly and in earnest, I held up my pencil for proportions, I softened lines, I looked at the negative spaces, and I concentrated and tried hard. I wasn't good at it but I improved and was proud of that. I packed up my pages at the end of the summer and shipped them home. That portfolio of drawings, made with the intention of truthfully rendering the model with my best concentration, would play a key role a few years later—and in a few chapters from here—when insights begin to come.

Accumulating
08.09.2012

3
SYSTEMATIC DRAWING

Between 1989 and 2013, I tried to engineer a new kind of art, a software art that created itself. I was incredibly excited by the potential of using the power of computer code to make art, yet in the process I recognized the limits of this kind of work. Many artists have used rule-based systems to make art, and unique creativity can spring from following rules; but in the end, my failure to realize an autonomous computer art-making program led me away from logical rules and pointed me inward. This story begins with the power of words, spoken and written in code, and the systems that emerge from those words.

Code loops and mantras

Sitting here in my studio on a warm midsummer night, steady rhythms of bullfrogs and crickets filling the air, light of a full moon shining through the window, tasting the few sips of coffee left in the mug beside me, I type the words that you are reading right now. Transferred from my mind to yours along a winding path, encoded in English, these words are triggering activities in your brain. You are reading, decoding the vocabulary, assessing the meanings, and forming your response. I am sitting and editing words, noticing what arises, imagining your response, and marveling at the power of transmission. As I see it, we are sharing this moment.

Mornings in the studio begin with drawing and meditation. Energy, ideas, and thoughts in my head need to be expressed and I convert them into colors and lines on paper. But tonight I direct that creative energy toward writing as I type these words into a computer and watch them appear on the screen. I think about all the words behind the screen, holding the software together and making the writing possible, loops of code, like so many mantras being endlessly repeated by the

machine. I start to feel a parallel between the words moving through my mind and through my computer. The sounds and syllables that form words in my head are the elementary particles of speech, their endless combinations giving words their variability and flexibility. Words hurt and words heal. Words bind agreements, claim property, and order individuals. Words carry mystical power for some and political power for others. And most recently, words control machines.

My daughter begs me not to say a word about her audition for the school play or I'll jinx it. I'm not even allowed to say "break a leg." Could my words really change the outcome? Some of my fellow Jews follow a tradition that prohibits the speaking or writing of the name of "G-d." Is this restriction kept mostly out of respect for tradition, or does it reveal a real fear of the power of a sacred word? The magician shouts the words "presto chango" to bring about a rapid transformation of physical reality, or at least the viewer's perception of it. And how many other religions and cults utter words from ancient languages in their ceremonies?

John Blofeld's *Mantras: Sacred Words of Power* outlines the ways in which many cultures have rarified and empowered certain vocabulary, attributing "creative, transforming, or destructive power to esoteric utterances ranging from mantras to magicians' spells."[1] Mantras are used to increase focus and quiet the mind, but some people believe that mantra practice also alters the world outside them. A mantra's power is often said to derive from more than just knowing the words, placing equal importance on precise pronunciation and rhythmic utterance. Many mantras are given by teachers for private use, not to be revealed to anyone by the practitioner, the internalized syllables energized by thousands or hundreds of thousands of repetitions. Mantras remind me of computer codes, small sets of words with strict syntax that are implemented in loops, and of how a machine's power comes from repeating these loops.

..............

1 John Blofeld, *Mantras: Sacred Words of Power* (New York: E. P. Dutton, 1977), 84.

The Circular Arrow—A Visual Mantra

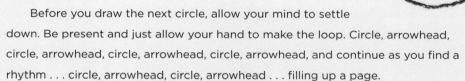

Draw a circle.

At the point where the circle closes, draw an arrowhead.

The geometric circle becomes a self-referential symbol, an arrow pointing back at its origin, or a cycle returning to the beginning.

Before you draw the next circle, allow your mind to settle down. Be present and just allow your hand to make the loop. Circle, arrowhead, circle, arrowhead, circle, arrowhead, circle, arrowhead, and continue as you find a rhythm . . . circle, arrowhead, circle, arrowhead . . . filling up a page.

If a thought comes up or your attention drifts during the drawing, use the moment when you add the arrowhead to point your attention back to the drawing process and return your thoughts to the beginning while preparing to draw the next circle. The circles don't need to be placed in any arrangement or even made the same size. They can overlap, or all be drawn as a stack in one place. Draw in whatever way your hand moves in the moment and see what shows up.

Keep making circular arrows.

The purpose of this repetition is to build muscle memory, to make the action of the hand so familiar that you can make circles with arrowheads using little or no attention, generating a separation in experience between the doing and the watching, and finally bringing awareness to the foreground and being able for the most part to remain in that state. The reversal of attention from making the circular arrows to watching them be made is analogous to the figure/ground reversal I described in the mirror practice in Chapter Two. Our attention, initially occupied with how the hand draws the circular arrows, begins to soften as the process becomes more familiar. As your hand moves, be patient; when the action becomes more and more automatic, the space surrounding the activity will broaden and you can rest in that space as your hand does the work.

Sit in awareness as the circles go by.

Words that do what they say

I first experienced the magic of computer graphics in the spring of 1984, in a small office in the Geology Department at Brown University, when I played with MacPaint, the Apple Macintosh computer's first drawing program. That afternoon, making pictures with a mouse, the results immediately visible onscreen, I understood how far a computer program could transcend problem-solving; software could have style!

MacPaint was the project of Bill Atkinson, part of the original Macintosh development team. Since interactive drawing programs were just being invented, I imagine he was given the job to make up a story in code about drawing on a computer, including his choice of tools and how they worked, all written out in instructions.

A story about a paintbrush, when translated to computer code, *becomes* a paintbrush. Media theorist Friedrich A. Kittler elegantly points out the expanded capacity of programming words to both describe and act: "To the degree that it appears in binary code, writing gains the enormous power to do what it says."[2] I fell in love with the idea of creating a literature that could not only expand ideas in readers' minds, but would be written primarily for their vision. In the right circumstance, the writing gains the agency to interact with the world. My words describing an artwork, repeated over and over again, deep in the computer's processor and memory, are displayed on a screen endlessly as visual mantras, similar but never the same.

............

2 Friedrich Kittler to Nettime Listserve, February 6, 1999, *On the Implementation of Knowledge: Toward a Theory of Hardware*, http://nettime.org/Lists-Archives/nettime-l-9902/msg00038.html; repr. in Readme! (nettime): ASCII *culture and the revenge of knowledge*, ed. Josephine Bosma (New York: Autonomedia, 1999), 60-68.

Drawing from point to point

Meanwhile, back in the studio, it has begun to drizzle and I can hear raindrops tapping lightly on the tin roof. My Mac mini humming quietly, peacefully and steadily, Buddha-like, repeating loops of programming words, connects me through the Internet to three other people using a video chat application. We sit in different locations meditating together, practicing the technique of mental noting, naming whatever sensory input arises: "seeing, hearing, seeing, touching, etc." The computer likewise pays attention to its sensory inputs, the ports where it receives outside data, "mouse movement, Internet data, mouse click, keyboard, etc."

To write a new piece of software, I often pretend that I am inside the computer and going through the steps of the program, noting what to do at each step.

Improvised Systems
02.11.2014

I make up a scenario like this: Here I sit, patiently displaying a paint program on the screen, showing a cursor that looks like a little pencil, waiting for input. When a human presses the mouse I get a nudge followed by a stream of data, a list of hundreds of x-y screen positions, all the places the pointing device is moving across the desk. I am programmed to simulate a pencil. No, I *am* a pencil. I connect the pairs of incoming points with short line segments, filling in pixels on the screen to resemble a thin pencil line.

The no. 2 pencil a child takes to school leaves a thin gray line as it is dragged across a piece of paper because a pencil is just a wood-encased graphite cylinder sharpened to a point. The line on the paper maps the route of the hand and the graphite is a visible residue of that motion. To draw differently—to make a thicker line, a softer graphite mark, or multiple simultaneous marks—would require differently engineered materials. From my point of view inside the software, I have no such physical constraints. This is where the fun and creativity opens up for the programmer: Instead of a pencil-mimicking line segment, what if our newly rewritten, fancy-programmed pencil drew a line of boxes, or circles of alternating colors, or a string of cute cat images pulled live from the Internet? It is up to us to choose how closely we want to map the lines drawn on the screen to the positions of a hand moving around outside the computer. Let's take a moment to do a practice and play with just how varied our lines can get.

Improvising Between Two Points and Finding the World In-between

Have fun with this elaborate connect-the-dots game! The instructions are simple:

1. Mark two dots on paper and connect them.

2. Repeat, connecting two new dots differently.

How many times? A whole lot. Connect the dots with so many different kinds of lines that you exhaust your immediate ideas (e.g., straight line, wavy line, dashed line, etc.), and then force yourself to come up with new ideas. Make a line in response to how silly this practice is. Make a thin line with intense focus, a crenelated line, and one line made of loops. Connect the dots with something you wouldn't call a line. Fill up a page. Work quickly.

I encourage you to have fun and get creative with how you connect the dots. Open your mind to paths, shapes, and rules that vary a great deal. Don't limit your rules to geometry. Draw lines that track changes in room temperature or your shifting feelings.

Observe your mind as you improvise. How do you choose what to draw next? How different will you allow it to be? What resists improvisation?

Begin to be aware of how you feel when you touch the pencil to the page and start the mark, then notice if thoughts arise as the line appears. Finally, check to see if you are still present when you reach the second dot.

Now quickly do the practice before reading on.

How easy or difficult was finding different ways to connect the dots? Can you continually come up with variations, did you struggle with each one, did the innovation come in waves, or did you make categories and employ a system?

Did you limit yourself to one pass or allow multiple passes when building up the connections? Did you use your senses, like hearing, to influence the variation of the line, or awareness of your breath to create fluctuations? This practice reveals our default tendencies, unspoken rules, and boundaries to immediate change. Notice your limits in one line and contradict them in the next.

Two points to infinity

I practiced this two-point practice on my drawing cards for years trying to spot similarities in my improvisations so I could group the lines that looked similar into families and give them names, like rake lines, spinning lines, or hatched lines. This kind of generalization made it easier to invent formulas for how the line should be drawn. For example, I noticed that sometimes, if I happened to draw with a straight line, I would then go back and draw short marks at regular intervals and at right angles to the line, a kind of shading or decoration added to the line. When I put this into code, the new tool drew a straight line with little hatch marks. Later, I let the hatch mark vary in response to how fast I was drawing. Playing with the hatch mark, I found tremendous visual variability, as computer drawing tools mix an artist's intention with chance operation in software; on the artist's side, the hand gestures vary, and in the software, the source code is easily tweaked.

Point to Point
09.21.2015

How far could my coding abilities, my imagination, and the computer graphics systems be pushed? I once made a "pencil of one thousand pencils," where one flick of my wrist was amplified by the code into a thousand lines on the screen. In another image, the simple, straight-line path of my mouse was converted on the screen into a line that wandered a zigzag path resembling a leaf falling from a tree. I have made the color of lines vary during drawing based on real-time stock quotes, local temperature, and the time of day. One superwide software paintbrush filled the screen with lines in one swipe.

In all my experiments with computer-aided drawing, one question arose repeatedly in my mind: Just how many possible drawing tools are there? By simply opening the space between two points, between two moments in drawing, I glimpsed an infinite number of possible drawing tools. What next? Should I develop more tools, or make more drawings with the ones I had already created? I needed some context within which to understand this systematic approach to art making, one that would also help me understand my own motivation to reduce my creative decisions to words and ideas. Luckily, I found that context and understanding within a recent art movement: Conceptual Art.

Conceptual Art and contemplative practice

Conceptual Art, a movement exploring the power of words and systems, flowered in the late 1960s and early 1970s amidst the cultural atmosphere of an industrialized world that was captivated by the engineering feats of the Apollo space missions and the nascent computer, pictured often in the background of television shows and advertisements as a large cabinet with blinking lights and magnetic tape readers. Information technology and the specter of systematic control were so prominent in 1968 that the Institute of Contemporary Arts in London presented a show called *Cybernetic Serendipity* to review the use of computers and software in contemporary art. In 1970 the Museum of Modern Art in New York held an exhibition entitled *Information* that explored new technologies and participatory

art (the audience followed written instructions), and that same year the Jewish Museum in New York City presented *Software: Information Technology: Its New Meaning for Art*, which also examined art made with logical procedures. To the new conceptual artists like Yoko Ono, Lawrence Weiner, Robert Barry, Joseph Kosuth, Henry Flynt, and Sol LeWitt, among many others, the "idea" was the art.

In addition to the rise in cybernetics, the United States in the 1960s also experienced an increasing cultural interest in meditation and mindfulness from various traditions and visiting Buddhist and Hindu teachers. The influence had already been felt in the mid-twentieth-century art world through pieces like Robert Rauschenberg's 1953 *White Painting* series, a set of large rectangular canvases covered in flat white paint, and John Cage's famous *4'33"* (1952), a musical composition about silence. A natural dialogue arose between Conceptual Art and contemplative practice; both direct our attention and then upend our assumptions about what we see right in front of us or what is happening in our immediate experience, in order to nudge us out of ordinary thinking and help us gain perspective on what is happening in our mind. Consider an artwork by Joseph Kosuth called *One and Three Chairs* (1965), made of three separate objects displayed in a row: a photograph of a chair, a wooden chair, and a dictionary definition of the word "chair" printed large on a poster. We might assume that there is only one "real" chair, and yet all three call to mind "chair." What can and can't be referred to as a chair? We might even imagine retitling the work *One, Three, and No Chairs*.

If the idea *was* the art, a constant dilemma for conceptual artists was how to transmit their ideas to others. Ideas had to be spoken, written, or made into an object if they were to be experienced, appreciated, or understood. A similar dilemma faces a meditation instructor trying to guide a student. We are not mind readers. How else besides pointing toward it through practices and metaphorical stories can a teacher explain in words what can only be experienced? How does one talk about the ineffable, in art or meditation?

Art that is presented as a set of instructions, parallels meditation instructions because the participant is not given an "answer" or a finished work but must follow the method himself or herself in order to come to an understanding. The same

uncertainty is also true of computer programming: the only way to know exactly what a program will do is to actually run it in a machine. The emphasis in all three fields—art, computer science, and meditation—is that understanding only comes from doing.

Many conceptual artists found it convenient to offer descriptions of art that functioned like guided meditations or directed a viewer's thoughts like a Zen koan. For example, notice the wonderful turn of phrase in this line from the conceptual artist Robert Barry, whose works are largely nonphysical: "*Nothing* seems to me to be the most potent thing in the world." Another piece by Robert Barry is about artwork, how it can't be described, but could easily be read as a meditation instruction on noticing attention:

> *art work*
> it is always changing
> it has order
> it doesn't have a specific place
> its boundaries are not fixed
> it affects other things
> it may be accessible but go unnoticed
> part of it may also be part of something else
> some of it is familiar
> some of it is strange
> knowing of it changes it[3]
> —Robert Barry, 1970

Again we see how the power of words can activate and direct the mind.

Another important conceptual artist Yoko Ono did pioneering work in many fields including performance, installation, music, and text-based art. She is a great example of the influence of mindfulness in art at that time, naturally combining

............

3 Barry's *Art Work 1970* is published in Lucy R. Lippard, *Six Years: The Dematerialization of the Art Object from 1966 to 1972* (New York:Praeger, 1973), 178.

introspection and art. In 1964 she published *Grapefruit: A Book of Instructions to Be Completed in the Mind of the Reader*, which included this piece:

MIRROR PIECE
Instead of obtaining a mirror,
obtain a person.
Look into him.
Use different people.
Old, young, fat, small, etc.[4]
—Yoko Ono, 1964

Mirror Piece resonates with the notion that our best spiritual teachers act as mirrors, reflecting our own mind back to us. In this piece Yoko Ono goes further by insisting on finding a variety of people, not a formal teacher, thus encouraging us to use the entire world as our teacher. The piece also points to intimacy between people, the effort that our human interactions require, and the service we can offer each other in being present and loving. If we experienced looking into another person like we were looking at ourselves in a mirror, how would we not share their feelings?

Another Yoko Ono piece from the same book that entangles intimacy and giving:

PAINTING TO EXIST ONLY WHEN IT'S
COPIED OR PHOTOGRAPHED
Let people copy or photograph your
paintings.
Destroy the originals.[5]
—Yoko Ono, 1964

..............
4 Yoko Ono, *Grapefruit: A Book of Instructions and Drawings* (New York: Simon & Schuster, 2000).
5 Ibid.

This piece, in its simplicity and elegance, encourages feelings of freedom in me. It challenges me to be unattached to my creations, to put my ego aside and to allow others to copy or reuse my work. Destroying the original points to the impermanence of things, a core Buddhist teaching. Ono's piece anticipates appropriation art, the using of preexisting objects or images with little or no transformation applied to them, and the practices of music sampling, remix culture, and eventually, the whole open-source movement in which computer code is freely copied and shared. One can imagine a culture shaped by this attitude, where peaceful interaction is the norm and art only truly exists when it is shared and when artists are unattached to the fruits of their actions.

Yoko Ono continued the conceptual artist's interest in dematerializing the object of art, placing the value of the work in what is imagined and the experience of imagining. In another piece, the artist cuts out the middleman of the paint and canvas, attempting to transmit to us directly what we might get from viewing.

PAINTING TO BE CONSTRUCTED IN YOUR HEAD
Go on transforming a square canvas in your head until it becomes a circle. Pick out any shape in the process and pin up or place on the canvas an object, a smell, a sound, or a colour that came to mind in association with the shape.[6]
—Yoko Ono, 1962

We could say that the real medium of this piece is "what can be seen and noted in the mind." When I follow the instructions and use visualization of the canvas shape to trigger my senses, the subsequent positive feedback loop that results from continuing to stay with and transform the canvas enlarges my definition of painting.

After becoming energized by conceptual art, I wondered if I could write a conceptual piece that functioned simultaneously as a meditation instruction, calling on both awareness and visualization. Practice Thirteen is my own contribution.

.............
6 Ibid.

Breaths like children
Allow for them
They rise on their own
Give them attention as they grow
Release them as they go away
Wait patiently for their return

Breaths
09.26.2013

Thought as Art

Sit quietly noticing your breath.

When thoughts arise,

frame them and hang

them on the wall.

Rational mystics

How does a conceptual artist transform the ideas in their head into forms that can be shared? Each artist struggles differently with the inherent separation between concept and object. If one of the original motivations of conceptual art was to undermine the commodification of art, what do these artists make to sell and support themselves? If the art is the concept, do they need to make anything at all? In 1968, Sol LeWitt painted directly on the wall of the Paula Cooper Gallery in New York City, forgoing the canvas and calling attention to the "idea," thus creating a legendary artwork that helped define conceptual art. As there was no object to sell or pack in storage, the wall painting didn't last—it was painted over when the show ended. LeWitt considered his art to be the set of instructions he had written that described how the painting should be done. Each installation was temporary but the piece could be installed many times and in many places. He employed teams of installers to make the wall paintings, further distancing himself from their physical realization. LeWitt was, in essence, thinking like a programmer when he wrote, "The idea becomes the machine that makes the art."[7] (In software art, this becomes fact.)

In writing about his automated approach to art making, LeWitt stressed that the idea, not its execution, was the area of his innovation. His use of assistants may seem mechanical and impersonal, denying us the pleasure of the personal marks that we associate with the artist's creative energy, but he was careful to assure his audiences that all the spontaneity of art making was taking place inside his mind. His famous piece titled *Sentences on Conceptual Art*,[8] first published in 1969, begins with the statement, "Conceptual artists are mystics rather than rationalists. They leap to conclusions that logic cannot reach." This sets up an interesting tension in his work between his inner, spiritual, creative process and the external, systematic, hands-off manifestation of that process. LeWitt was not interested in the beauty of the final drawings. He said, "If I give the instructions and they are carried

.............

7 Sol LeWitt, "Sentences on Conceptual Art," *Art-Language*, vol. 1, no. 1 (1969).

8 Ibid.

out correctly, then the result is OK with me."[9] His work seems to appeal more to viewers' intellect than to their sense of beauty.

LeWitt's early strategy for wall drawings used mathematical combinations of a few simple elements like horizontal and vertical lines to show all possible ways those elements could be arranged, but at the same time creating a finite number of variations so that they could be drawn in a reasonable time by hand on a wall. In 1998 I was lucky enough to have some of my drawings exhibited at the Sandra Gering Gallery in New York City in a group show that featured LeWitt and Hanne Darboven, a German conceptual artist who often wrote out large tables of numbers by hand. LeWitt's piece for the show was a wall drawing called *All Two-Part Combinations of Arcs from Corners and Sides, Wall drawing #842, white crayon, black pencil grid, black wall, 14x18 ft.* The drawing in the show was installed on the wall—by Anthony Sansotta, one of Sol LeWitt's long-time assistants, and by the Gallery Director Russell Calabrese—by following the instructions, which also functioned as the title.

This LeWitt drawing, white lines on a large black field, created a strong presence in the gallery. That presence was beautifully offset by the simplicity of the system it described. Until that show, I believed that conceptual art was about the idea—the concept—and thus that the drawing on the wall was only there to display the idea. I believed this until one day during the show, when I found myself alone in the gallery in front of that wall and my vision was filled with black paint and the pebbly, waxy marks of the white crayon. At that moment the piece seemed to open a door in my mind. Rather than the concept being processed like art in my brain, I felt a sense of integration—my eyes and body were involved, a union between the concept and the materials, neither one standing alone. My view transitioned from an analytical appreciation of a system called "art" into an utter, complete presence with an artwork. The conceptual system was the engine.

Choosing concrete rules, as LeWitt did in choosing horizontal and vertical

............
9 Lucy R. Lippard, "The Structures, The Structures and the Wall Drawings, The Structures and the Wall Drawings and the Books," in *Sol LeWitt*, exh. cat., ed. Alicia Legg (New York: The Museum of Modern Art, 1978), 24.

lines, gives structure and direction to the work, but the material presence is undeniable. This presence, for some, *is* the work, and the conceptual system is only the vehicle. The reason I make a drawing every day instead of just think about making a drawing is to experience this presence, the novelty that arises from art being made, from the set of materials arranged on a page. I once asked Mr. LeWitt why he hadn't explored digital systems, since he understood computers could rapidly produce millions of combinations. He smiled and said, "I haven't gotten there yet," knowing I'm sure how much more there was left to explore by being present with materials.

Every icon

Sol LeWitt's art-making systems employed mathematical combinations as a way of selecting and arranging visual elements from a larger collection. He described the systems hidden in his pieces through the work's titles, which doubled as the instructions. For example, *Lines in four directions (horizontal, vertical, diagonal right and diagonal left) & all their combinations* (1977). As an ambitious computer artist looking for ways to automate creativity, studying his systems provided me with great ideas for software projects because it seemed like he was writing software to make his work. I wanted to automate his combinations and do something bigger and better using the new digital technology; I wanted to use the power of computers to show all the combinations of a set larger than LeWitt could dream of.

I had in mind a computer program that could arrange and rearrange pixels, the way LeWitt's systems rearranged lines, but my display wall would be a video screen. I knew that every digital video frame was a grid of pixels (a "picture element," one dot in the frame of a digital image—at that time 640 pixels wide by 480 pixels tall was a common size for video). The color of each pixel was held in computer memory as a number, the combined brightness of the red, green, and blue light at that point in the scene. Why not, I reasoned, make a program that would count up from zero at each pixel, moving through all the colors and, by showing all colors

sequentially at each pixel, eventually show all possible video frames? It was exciting to think of a machine that could iterate through every possible video, revealing images of things not yet seen, images of the distant past, and images of my imagination, all there even now, in the matrix of all possible video images.

I quickly wrote a program to show me how many total frames of video there were and I got the surprising result of NaN—not a number. The number held too many digits for the mainframe! That was my first clue that mathematical combinations quickly yielded unimaginable results. To make the problem more manageable, I reduced my ambitions, cutting my image from 640×480 color pixels to 32×32 black and white pixels. I chose 32×32 pixels because it is the size of the original Macintosh computer's desktop icons, those little pictures like the trash can, the folder, and the MacPaint icon. How many desktop icons could there be?

If I could write a program that would display all the combinations of 32×32 pixel images, I would have at my disposal a catalog of all the possible desktop icons. I would get to see and choose from all the icons yet to be discovered. What an advantage! The program I wrote, called *Every Icon*, progresses by counting. Starting with an image where every grid element is white, the software displays combinations of black and white elements, proceeding toward an image where every element is black. *Every Icon* is still operating and can be seen online at http://numeral.com/everyicon.

All Four Pixel Images

Let's try a simple experiment. How many pictures can be made using four pixels? Each square below has four pixels, which can either be white or black. The first row of squares and the last square are already filled in. Your practice is to fill in the remaining eleven so that all the squares have different pixel arrangements. I guarantee you that only sixteen arrangements are possible.

It took about half a day to write the code that ran and displayed *Every Icon* and in the evening I set it to work, hoping to see some interesting icons by morning. Starting with a white grid, filling in combinations across the top row, and proceeding row by row, *Every Icon* should continue until the grid is fully black. When I got up and checked the progress of the program, I thought something was wrong because the little black boxes were still inching along the first row of the 32×32 grid. I did some quick calculations and discovered that it would take many months before finishing all the icons on the first row. Continuing to check the numbers, I was both delighted and terrified to discover that finishing the second row of the grid would take hundreds of millions of years! How long would it take to complete all thirty-two rows?

The 2×2 grid in Practice Fourteen has sixteen possible arrangements. We can see them all. A 3×3 grid has 512 unique combinations, which could be colored in quickly by an ambitious person but would be a lot more work than the 2×2 grid. The combinations grow quickly. A 5×5 grid has over 17 million ways to be filled in, which would be a serious endeavor to finish but not beyond human ability. By the time we get to a 32×32 grid, the number of different pictures is greater than the number of atoms in the universe. The total number of black and white desktop icons is 2^{1024} or 1.8×10^{308} in scientific notation, a number with 308 decimal places!

The enormous magnitude of this set only began to dawn on me when it was activated and I could appreciate in my own time just how far it had to go to fill in the first line of the grid. For me to begin to appreciate the futility of computing every image, I had to experience the slow progression, not a written description or a video, but a piece of software art that I could see would take eons to complete. I understood that pure computing power would not show me the "perfect" image because there was not enough time for me to see all the variations, and besides, even if the algorithm made the selection for me, how would I know if a better image had been discarded?

Remembering a similar conjecture about all possibilities, I went and dug up my copy of *The Library of Babel* by Jorge Luis Borges, a story about a library that holds every possible book. The library's first book is filled with *A*s and the last volume is

filled with *Z*s, and in between are all the books that can ever be written. Among every other possible piece of literature, the library must also include:

> The minutely detailed history of the future, the archangels' auto-
> biographies, the faithful catalogues of the Library, thousands and
> thousands of false catalogues, the demonstration of the fallacy
> of those catalogues, the demonstration of the fallacy of the true
> catalogue, the Gnostic gospel of Basilides, the commentary on
> that gospel, the commentary on the commentary on that gospel,
> the true story of your death, the translation of every book in all
> languages, the interpolations of every book in all books.[10]

Borges played with the impossibility of knowing this library, but his colorful self-referential descriptions made the search for a way to conquer it even more tantalizing to me. What if I could write a computer program to move through the library of all possible images in some systematic way?

Every Icon became my first big "hit" in the art world, extending my practice of conceptual art into the digital realm, because it questioned the nature of image creation and foregrounded the viewers' mortality. I think the immediate appeal of *Every Icon* is the feeling of excitement, the promise of seeing an overwhelming number of interesting icons, followed by a somehow satisfying feeling that computing has finally overcome the limits of image making. Once the amount of time it takes to see all the images is disclosed, I have feelings of irony and wonder at how a tiny square could contain so many images, like a tiny atom containing so much energy. I think the deepest appeal is the knowledge, from watching the speed of the advancing icons at the top and the distance to be covered, that if the viewer waits their whole lifetime, they will see only a fraction of all that is possible. Some of my collectors have purchased copies of *Every Icon* and set the starting date to a special occasion like the birth of a child. The piece, hanging in the home, constantly advancing, is a kind of odometer, marking the passage of life, an artwork

............
10 Jorge Luis Borges, *The Library of Babel* (Boston: David R. Godine, Inc., 2000).

that grows with the viewer. The work was widely written about and shared online, with perhaps my proudest moment being its inclusion in the Whitney Museum of American Art's Biennial exhibition in 2000.

After writing *Every Icon* I took time to reflect on what I had encountered. I accepted the fact that there were unknowable things, but I asked myself: Were there things in the world that were *unimaginable*? My ego was hard-pressed to let that one go—I was so identified with being an artist, whose definition and currency seem to entail imagination. Was there really something I couldn't imagine? We can't always know things, but can't we always imagine them? No. We want to think we do, but the answer is we can't. The set of possible images is so large it is beyond imagination.

This realization took a while to really sink in. It was my first real taste of vastness. I fought it. Why not speed up the process and have the computer display billions of icons a second, skip through them somehow? If I somehow obtain unlimited computing power to display icons at a rate that would show a significant number in my lifetime, they would have to change faster than the speed of light. Even if I were to hyper-accelerate streaming through the data set by skipping big chunks ahead, a more significant bottleneck is the slower speed of my visual system, and slower still is my mind's ability to recognize a "good" icon. If they went by too fast, I'd miss what I was looking for. As I thought through the possibilities, I had to face the fact that I could never look through a tiny fraction, let alone see them all. While this felt disappointing, I realized that I could handle the fact that I'll never see all the icons—it felt like accepting that I'll never eat at every restaurant in New York City. The harder part to accept, because I identify so strongly with my imagination, is that the set of all possible icons is not only bigger than I imagine—it's bigger than I *can* imagine.

So the icons are out there but I can't see them all? It started to feel like a Zen koan. What do all images look like? As I was discussing with a friend the inordinate amount of time it would take to see all the icons, she said that *Every Icon* described a *kalpa*, a Sanskrit term for an inordinate amount of time, an amount of time that couldn't be conceived. She told me her version of a Buddhist story

explaining the kalpa: Imagine a huge stone mountain, sixteen miles on each side. Once every hundred years a monk appears and gives it a wipe with a silk cloth. A kalpa is the time it takes for the mountain to be worn away.

When I think of how Buddhist cosmology has tried to grasp that which is outside the universe, to describe ideas larger than imagination, I am reminded of the mantra in the last lines of the *Heart Sutra*:

> *Gate, Gate, Paragate, Parasamgate, Bodhi Svaha!*
> (Gone, Gone, Gone beyond, Gone utterly beyond, Joyous Awakening!)

Interpretations of this powerful line vary and there are many elegant commentaries and essays about the depth of its meaning. To me this mantra guides the practitioner to ponder the relationship between "what can't be imagined" and "enlightenment."

Start where you are

Every Icon changed my creative practice from pushing software in order to accelerate image making to appreciating the value in each step of the creative process. If images existed that I would never see in my lifetime, then each image I saw was important. I began to regard each drawing I completed as one instance, one entry in the vast catalog of all possible images. In his 1991 film *Prospero's Books*, a cinematic adaptation of William Shakespeare's *The Tempest*, Peter Greenaway showed a series of exotic books that were kept in a library on a magical island and revealed just enough of their contents to have me wishing the fantasy books were real. Among my favorites are *The Book of Colours*, where "the pages cover the spectrum in finely differentiated shades," a *Bestiary of All Past, Present, and Future Animals*, and a *Book of Motion* that describes, in animated illustrations, all possibilities for

dance with the human body. I was captivated by the way the books had activated, living components, and I was inspired to create just such a book. I hurried home right after seeing the film and started drawing on a large sheet of paper. It was the first page in my *Book of Compositions*, a book filled with grids of squares, each containing different compositional structures. It took a few weeks to finish the drawing because I tried to invent new compositional categories for each square, such as centered composition, objects at depth, and corners only. While I was working, I began to think again about how to write a computer program to invent compositions. What were my rules for filling each square? Could I program these rules?

Each in its Own Box
02.05.2013

Book of Compositions

The practice here is to cut a piece of cardboard into a three-inch square. Use that as a template to trace around and lay out a grid of squares filling a large page. Once the grid is done, switch gears and begin filling the squares with different compositions, trying to have fun as you go. Work quickly, spontaneously, and sketch unique compositional structures, patterns, and shapes in each. Play one idea off the next and don't repeat any. Do you notice the rules that you make for yourself? How would you describe the progression of ideas?

What would automated creativity look like?

It's been twenty years, but I still can't give up on *Every Icon*. I haven't stopped brainstorming to find clever strategies to filter out the interesting icons: some arrangements of pixels that we would call "pictures" separated from the arrangements we would call random or noisy. How do I write a program that deploys good taste and a good eye? The "default" way of finding an icon is to use my own creative mind to merely dream up an icon—in other words, to use my imagination. Can that be automated? Can the machine have its own ideas about what an interesting icon is?

If I program any shortcuts to filter *Every Icon* to search for recognizable pictures, I must base the rules on my own aesthetic judgment, my own preferences, and my own ideas about what I am searching for. How is this any different than me making up the icons from scratch? Without my preferences, the machine cannot decide what it wants. Isn't that just me picking out what I want?

Is it possible to program an artificial intelligence that can do creative work? Here the problem becomes a question of how to judge artistic "success," which is not always reflected in the image at the end of the process. An artist's work is best and most fully understood in retrospect, when one can see a long arc, understanding the directions explored, the dead ends, and triumphs—even the artist's sketches and discarded works aid our understanding of the winding paths the artist followed, half repetition and half discovery.

I once stood for hours in the Museo Nacional Centro de Arte Reina Sofía in Madrid, Spain, with my back to Picasso's famous *Guernica*, because on the wall opposite were displayed a series of sketches showing the evolution, from very realistic to final abstraction, of the horse's head that appears in the middle center of the painting. Picasso's sketches are a tour de force of individual visual evolution, a lesson in how art forms in a feedback loop between mind and visual form on paper. I suddenly saw that a computer program that could innovate with directed vision would need to do more than filter pixels. But just what qualities would have to be present in a body of computed works to convince us the program was creative? This remains an open question that inspires my work to this day.

When I began my research into writing a creative AI (artificial intelligence), I saw two routes to solving the problem. One was a top-down approach, to create an expert system that chose from a library of marks and created images by varying rule sets. Beginning in 1973, the painter Harold Cohen developed just such a software program called AARON, a program he continues to grow and use to generate images. His machine assembles images, but he readily admits they are derived from the input and intentions of the artist and not the software's own sense of self. This program, no more complicated than a series of logic statements and random switches, creates fascinating images in collaboration with its inventor.

The other approach was to look for ways to make random-looking systems somehow fall into order. Think about how an anthill or beehive looks chaotic, each component doing its own thing, but from all that activity comes an elaborately organized structure. No one tells each fish in a school where to go, but the whole body of fish seems to move together. Was there a computing process that I could find from which such order would emerge?

Chip Party
06.29.2010

I spent about five years writing my own programming experiments to try and find such a system. One work in this series, *CPU* (1999), continually maneuvered squares of various colors around the screen to see if and when order would emerge. What I learned from this dynamic pattern engine was that the computer code was only half of the equation in determining when something interesting had formed. I noticed that, without thinking about it, my mind makes rapid decisions about the quality of patterns, placing value on those deemed to be pleasing and attractive, and discarding those considered chaotic or boring. This emergence of preference happens in the mind, making a human mind crucial in distinguishing pattern from noise. What is emergent behavior without someone to recognize it?

How did my code experiments change my own drawing practice? I felt more freedom to allow anything to happen on the page—to draw anything I felt like, because I trusted my intuition to recognize what was working and what wasn't. The code exploring emergent behavior reinforced the importance of my eye in the creative loop.

What did I learn from trying to automate the creative process in computer systems?

First, I learned that my reductionist desire to create an image-making machine was overwhelmed by the exponentially expanding number of choices I faced creating it. I don't believe there is a way to proceed with making a drawing that removes the maker from the equation. In other words, in my creative work, I can't escape myself. For a machine to improvise, it must be given rules, structures, and limits within which to work. The conditions that the person designing the software chooses to set will reflect that person's interests, desires, and intentions and similarly affect the results.

Second, even if computers aren't artists yet, they are still instruments for searching through large data spaces. Every possible digital image—every digital video, every photo, every drawing—exists as a string of numbers. Filtering through

all possible digital images offers discoveries much like sending satellites to other planets does. However, until an algorithm can be written to search image space for coherent and culturally significant images, artists still have a vital job to do in setting the conditions for success. Interesting art is more than just searching for novelty; it can also involve current social conditions, fashion trends, and even global politics. Perhaps the system best suited to select art for humans will remain the human mind.

Finally, in the process of automating image making, my attention shifted from looking outward at computers and trying to solve a universal imaging problem, to looking inward at my own motivation and trying to decide what types of images I was interested in creating. I realized that my creative work is, at its base, a record of my own set of choices made from all possible choices. The limits of the search outward ultimately led me to value my own creativity and to turn inward to try and solve the mystery of where that creativity originated.

Looking back on the years I journeyed into the machine, learning to write code and trying to get a device to do the inventive work, I now see that I was seeking what I already had. The spirit of creativity showed up as a contrast to the descriptions I tried to make of it in code. By trying to articulate in code what I most valued in creative decision-making, I became clearer about how I was creating in my daily drawing. From this realization, I gained a deeper trust in the improvisational drawing practice that we explore together in the next chapter.

4
IMPROVISATIONAL DRAWING

The early twentieth-century painter Paul Klee wrote, "Art does not reproduce visible; rather, it makes visible."[1] His notebooks are filled with insights about the nature of art, uncovered through his lifelong practice of painting and drawing, that offer us a map of artistic expression combining elements of color theory and geometry into his unique style. By studying his own creative volition, Klee tried to identify general rules for drawing and, in doing so, developed his general theory of artistic practice. In his lecture notes, he traces a feedback loop that starts with the creative impulse first arising in the artist's mind; then, that creative inspiration is transmitted by muscles through the hand to the paper, touching off a "cosmogenic moment" when a mark is born and taken back into the eyes; and finally, the mind reacts to what is seen, triggering the next impulse. Klee's margin notes elaborate the creative and the contemplative goals of each step. In the course of his career Klee observed nature, wrote theory, and carried out rule-based practices, but the drawings and painting of his mature practice came to rely entirely on a "thinking eye," part rules and part improvisation. His diary entries show that his creative direction was based on an understanding that ultimately all experience was a product of the mind: "Wishing to render the things that can be verified, I limited myself to my inner life."[2]

The lectures and practices published in the notebooks, collectively titled *Contributions to a Theory of Pictorial Form*, were developed and presented over the course of Klee's career at the Bauhaus—the German art and design school whose faculty included successful artists Walter Gropius, Wassily Kandinsky, and

..............

1 Paul Klee, *Schöpferische Konfession* (1920), *The Inward Vision: Watercolors, Drawings, and Writings*, trans. Norbert Guterman, (New York: Abrams, 1959), 5.

2 Paul Klee, *Notebooks Volume 1: The Thinking Eye*, trans. Ralph Manheim (London: Lund Humphries Publishers, Ltd., 1961), 461.

Autumn flow
12.04.2009

Johannes Itten—where he taught from 1920–31. Especially relevant to our study here of the relationship between drawing, mindfulness, and finding the inner path of expression is his notebook entry from July 3, 1922, on "The Organization of Differences into Unity" that examines methods of overlaying form and content. About finding this deeper congruence he writes:

> Having gained new strength from my naturalistic studies, I can venture to return to my original field of psychological improvisation. Now that I have only the most indirect ties with a natural impression, I can venture once more to express whatever happens to be weighing on my soul; to record experiences that might be transposed into line even in the darkness of the night.[3]

What is this inwardly directed psychological improvisation that he refers to? Klee asked his students to make detailed visual studies from life so they could discover the unstated rules that govern processes in the visible world. He warned his students about how much effort would be required of them to be able to uncover nature's many purposes for growth and change. Comparing his approach to a life scientist using dissection to look at the internal parts of specimens, Klee encouraged his students to look through the many layers of their subjects for what was concealed. He then turned this natural analytical approach around, aiming toward gaining personal insight and only afterward focusing on surface appearances. In other words, having practiced and become familiar with rendering the likenesses of physical objects, his psychological improvisation is an inward look, a self-investigation, a process of removing layers and stories, looking for the essence inside, and *then* returning attention to physical materials to create a visual representation congruent with what was found inside. Klee says art is given form "in order that it may function, in order that it may be a functioning organism,"[4] and so it can achieve resonance in parallel with nature.

3 Ibid., 451.
4 Ibid., 453.

How do we practice this kind of improvisation? Is it just scribbling whatever comes out? Does that count? No. Improvisational drawing is simultaneously making marks and being aware of marking. The word improvisation may conjure an image of complete freedom but the beauty of improvised solutions lies in how the materials at hand transcend their inherent limitations. Boundaries give structure for freedom to hang on.

Chapter Three's "Book of Compositions" practice (Practice Fifteen) was a bounded improvisation. Look back at your sketches. Did any of your drawings go outside the boundary of the box? How closely did you follow my rules? Klee muses, "No doubt one can make a picture for the sake of the rules. But there is no artistry in that. You must take account of everything that transcends the rules. The actions that transcend the rules play a different role than the others."[5]

We get our first real taste of novelty when we take actions that challenge our internal rules. This kind of raw creativity is not always sweet or pretty, and we may react to something new with a wide range of emotions.

............

5 Ibid., 453.

Going Outside the Box

Make a 4″×4″ square.

Only draw straight lines inside the square.

Limits define improvisation

Beginning art students are often challenged to make drawings using objects that are not typically considered drawing tools, such as a chopstick, a paper clip, or a piece of cardboard; within these artificial limits, the student finds all kinds of creative ways to repurpose the implement, leading to a whole vocabulary of new marks and application techniques. From the scant provisions of a student's life, great variations grow. If narrowing the field of choices can spark creativity, how do I set the right limits to fuel my own improvisations? I recognize the limits that come from the qualities of the materials I have chosen, such as the various colors and hardness of pencils, the roughness of the paper, or the width of the brushes on the drawing table. I might also be limited by how big a sheet of paper I have, the amount of time I can put aside for drawing, or my own doubts and fears. There may be even more universal limits such as popular taste and social acceptance.

If limits define improvisation, our choices of materials and methods should be considered as equally as the composition or subject matter. Teachers often ask students to make many drawings of the same object with a wide variety of materials. The impact of choice is made clear when a student compares the different feelings they get from drawings in charcoal, ink, pencil, and colored pastel. By setting tight limits on what can be drawn, the mind is focused on what it feels like to work inside and outside of expectations. Making art with physical materials presents no shortage of limits—years of practice may be required to master the techniques of media like oil paint or the variabilities of wood or stone carving. Mastering our inner resistance, our fears of criticism, and doubts about our talent may take equally long.

Opening my perspective inward, I am aware of many of my habits, such as constantly centering my subject matter in the frame or starting every drawing with a 9H-pencil contour. Once I identify one of these tendencies, I use it as a limit and any resistance I feel to changing it becomes an improvisational boundary to play with and transcend. My art benefits from continually noticing and giving attention to resistance; for example, as I improvise along from point to point, am I resistant

to having one line cross another? Do I resist making a simple but satisfying drawing more complex because I'm afraid I'll ruin it? Regular drawing practice helps identify and work with my unspoken drawing rules.

Improvisational drawing balances between the known and unknown, the scribble and the ruler line, an exciting place of discovery between comfort and surprise. When I think about how to describe improvising on the inward path, the image of Paul Klee's well-known lithographic print *Tightrope Walker* (*Seiltänzer*) from the portfolio "Art of the Present (Die Kunst der Gegenwart)," 1923, comes to mind. In that print we see a lone figure holding a balancing pole crossing the top of the image, high above structures that look like scaffolds and ladders. Consider this acrobat making a dangerous crossing as a metaphor for living our daily lives where we must balance risks from the outside—for example, an audience's approval—and risks from within, such as self-doubt and satisfaction with one's work. What is the cost of a fall? The walker is perpetually on view in a circus atmosphere, never reaching the other

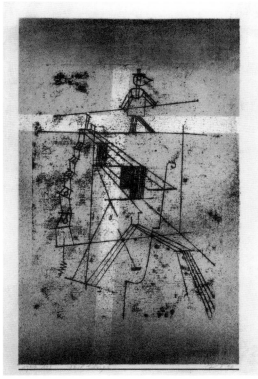

Paul Klee, *Tightrope Walker* (*Seiltänzer*), 1923
©2016 Artists Rights Society (ARS), New York

side, and having to exist in a stable equilibrium. This creative high-wire act reminds me of my own attempts to satisfy my artistic curiosity while trying to find supporters who want to buy my artwork. Thinking even more broadly, am I not always balancing my own wants with my need for approval?

Improvisational drawing performs a balancing act of discipline and letting go, remaining mindful of the actions of the hand while trying not to be the one

"doing" the drawing. How is it possible to observe the drawing happening but not think about drawing? Being aware of the doing but not being the doer seems contrary to most ideas about how to create. However, this practice of allowing the drawing to arise can be mastered. Let's start with the breath.

Just Sitting
08.13.2013

Not-breath Awareness

Try this simple not-breathing awareness practice to find out how to allow your breath to arise even while paying it close attention. When I began to practice meditation I was given the very common instruction to sit and notice my breath. When I paid attention, I found it very hard not to try and control my breath, almost to the point of making myself hyperventilate from the increased attention. To prove to myself that my body would breathe automatically, I sat and didn't breathe. If you try this, please don't hold your breath too tightly; just resist gently. Start by breathing in very deeply and slowly letting it all out. Everything is calm. Your body is circulating fresh oxygen. Sit patiently.

It may take more than a few seconds but you will begin to notice the signals your body starts sending you to alert you to the need for air, such as a tightening in the solar plexus, muscle twitches, lips tingling, or a speeding up of the heart rate. Even if you offer light resistance, at some point your body will just have to take in air without you making any conscious effort at all. Watch that happen a few times. Play with the resistance but not too strongly. I found this to be a good way to convince me that my thinking, dialoguing mind was not needed to get breathing done. In fact, breathing is what the body is busy doing all day when we are thinking about other things. We just don't notice. The question I ask myself is: Knowing this process is automatic and ongoing, can I sit and be aware of the process occurring, giving it attention but not contracting the muscles or in any way interfering, like a guest in my own house? Take some time to sit and be aware of your body breathing.

You may remember that I began making improvisational drawings in 1999, not for the sake of drawing but as research to uncover my unspoken drawing rules to use in my ill-fated creative AI programming project. It was luck that guided me to combine introspection with improvisation. Only later, when I had a more formal sitting meditation practice, did I find the value in adding the mindful breathing that I described in the last practice. Improvisational drawing just feels very natural to me, like drawing with the joy of a child, and yet when brought into awareness, the practice continually yields insights. In the beginning I just sat at the drawing table and watched, mostly curious about what would appear. As I became more self-conscious the drawings were less spontaneous. I was frustrated because I wanted to see good drawings but I knew I couldn't force them. It turned out it was this strong desire for a good result that prevented the good results from happening. The more I wanted the drawing to be good and the more I fretted when it was going wrong, the less freedom I had to simply allow my expression to flow. I found that a short period of sitting meditation, without drawing, paying attention to allowing the breath to arise, worked for me like a kind of cross-training, like an athlete using the gym to build strong fitness that benefits all aspects of a sport. After quietly sitting and noticing my body breathing, I had a greater capacity to sit and allow my body to draw.

Growing Improvisation

I listen as my daughter explains her drawing to me. "Blue surrounded by orange, its opposite, and orange surrounded by blue, then red with green around it and green with red around it, and all in a square."

"Very nicely done," I say. "So organized."

It's not like we don't make rules for ourselves. In fact we make all kinds of rules, fall into habits, and simplify repetitive tasks in order to manage and explain the things we do. In this practice, we try to use improvisational drawing to reveal some of those unspoken rules, limits, and tendencies.

Sit quietly, take a few breaths, and when you feel ready make a vertical line followed immediately by two or three additional marks in relation to the first. Just let the marks flow and try not to think about what is developing. After a few marks, make a new separate vertical line and continue to explore new marks in relation to it.

Be like the tightrope walker and balance between resistance and insistence. Use a little energy to get yourself started but keep your head, and spend more time observing closely what is appearing but don't add commentary. Feel the drawing grow.

Repeat the practice ten times, each time adding more and more marks and continually allowing the drawing to get more complicated. Stop when you feel yourself judging or shaping the drawing and start over with a clear mind and a new vertical line.

What additional marks did you make? Lines or other shapes? Did the marks touch the line? Did they intersect? Were they perpendicular to the vertical line or at angles? What do you notice about the way you work?

The Coltrane Effect

In my bachelor days, living alone in New York City, teaching computer art, and doing freelance coding for all the new dot-com start-ups, I used to love to go out late at night and visit jazz clubs around the city. I remember hearing many magical performances while nursing a Myers's rum and tonic along the narrow bar at Bradley's on University Place, or tucked away at a back table downstairs at the Village Vanguard with a glass of bourbon and Marcus Roberts playing piano up front. Maybe it was nostalgia for my childhood in Louisiana that attracted me to jazz, but I think it was the resonance I felt between my creative life and the free flowing, in the moment, back-and-forth kind of improvising that characterizes a good jazz set. I remember picking up a pen one evening, sitting and listening to Kenny Barron on piano and not being able to stop myself from following his line with my line on the back of the club's flier. I sat there in close proximity to a group of artists, all of us trying to create beautiful novelty within the structures of our instruments. That feeling is also echoed in the feeling of a Buddhist *sangha*, where everyone meditates together. That night, with Barron on piano, I was moved by the music and somehow connected to it through my creative practice. Now I rarely travel without paper and pencils because I have learned to tune into many situations and use the natural vibrations, musical or chaotic, as partners for improvising lines.

Since that night in the club I have explored many connections between musical improvisation and meditation. One musician who embodies this connection for me is the legendary tenor saxophonist John Coltrane. It is appropriate to discuss his work in the context of improvisational drawing because he was personally so interested in the connection between states of mind and the power of music. He was methodical in his approach and constantly practiced new ways of creating sound. My favorite Coltrane album, *Meditations*, released in 1966, functions for me as a kind of soundtrack to sitting meditation practice. The album opens with a free jazz improvisation featuring two tenor saxophones, Coltrane and Pharoah Sanders, almost like two voices battling in one head. The track is dense with

arrhythmic lines crossing and undulating, sometimes forming coherence, then leaving it off again, and winding through a long ascension that feels like an agitated mind failing to settle down. The sounds can be trying and uncomfortable at times, but they are undeniably passionate. This is a good place to listen and not judge— patience is rewarded.

The album taken as a whole progresses toward more linear and melodic movements—similar to the turmoil I experience when I first sit down to meditate and begin to calm my mind—through beautiful lyrical and peaceful moments with the final track, "Serenity," ending the whole forty-plus minutes' meditative journey with peaceful elated tones. *Meditations* could also be listened to as a catalog of Coltrane's own inner ruminations on musical possibilities, featuring many examples of his signature style such as overblown notes, loud squeaks, and playing several notes simultaneously. These inventions are the vocabulary of his improvisations.

Coltrane was a master at combining sounds but had the greater vision and desire to cross the line into something unheard. In a 1960 radio interview, he discusses his improvisational strategy: "There are some set things that I know, some devices that I know, harmonic devices, that will take me out of the ordinary path, you see, if I use these, but I haven't played them enough and I'm not familiar with them enough yet to take the one single line through them, so I play all of them."[6]

..............

6 Carl-Eric Lindgren, "Interview with John Coltrane Part 1" (Stockholm, March 21,1960). A recording of the interview appears on the album *Miles Davis in Stockholm*, 1960, Dragon Records.

Chasing the Coltrane Effect

Play a recording of John Coltrane's "India" from the album *Impressions* (or really any Coltrane after 1961) while sitting quietly and allow a drawing to emerge. Although you're not trying to illustrate the line of his music, or even react to it, try to feel how freely he traverses this tune, noticing the changes in tone and the way he moves from note to note.

When the song is over, see if any of that spirit was transmitted into your line or composition. Did you feel permission to be more open to experiment or get outside of the ordinary while this kind of music was playing? Did any forms or figures emerge that you did not expect?

Noticing resistance and setting the hand free

How hard is it to allow a drawing to grow on its own and not direct my hand or continually judge what appears? I find it especially challenging to let my hand loose when I call my attention to the process. Sometimes I sit down to draw and no matter how hard I try (or don't try), I can't get my mind clear enough to let the drawing spontaneously begin. What then? One strategy I have is to reverse fields and turn my attention to look directly at what I can't ignore. I draw a picture of what is directly on my mind, in a cartoon form or even something more elaborate, an illustration of the concept, something realistic, diagrammatic, or symbolic. For instance, if I am upset about a possession of mine getting lost or thrown away, I draw an image of that thing, or the trash can, or the person who took it, and sometimes I will see the impermanence of things and let it go. If I am nervous about making a presentation in front of a group, I draw a stick-figure audience and see the fear in my own mind. I do what I have to do to recognize the obvious. Calling attention to what is blocking me from free improvisation helps to unload my mind and makes it easier to get to clarity and calm.

But wait! By focusing on the "problem" I may have been improvising without knowing it, and the work may already be underway. It is easy to form a clear vision for drawing what we resist because the resistance is the very thing that won't go away. So let's look squarely at it and name it for what it is. When I become annoyed by my lack of ability to be calm and improvise, I can channel and unleash that strong annoyed energy on paper. Sometimes that is the very spark I need to get my work going. Surprisingly, by turning, looking at resistance, and releasing, I create a flow state. The resulting drawing may not depict anything recognizable, but the composition, line quality, and colors will tell the story. The thick, rapidly scribbled pencil marks and torn bits of paper resulting from my angry attempt to draw a trash can do more than depict a household object—the mess testifies to my anger. Ram Dass, the great spiritual teacher and author of *Be Here Now*, spoke about how the subtleties of our mood are overlaid on everything we do when he said, "If you do what you can do, but only with a sense of frustration because you can't do

more, what you are transmitting, with the very thing that you are doing, is that frustration."[7]

When I draw out the feelings keeping me from improvising, I can see frustration in the marks. Drawing the obvious things that bother me often allows me to let them go, and then guess what happens in the next drawing?

Once I am reasonably clear and able to allow the drawing to arise, flow is established more easily and many options for improvisation open up. Discussions of improvisational drawing may center on limits, but the practice itself is unlimited. Each drawing is special because the uniqueness of the lines is a record of the uniqueness of the moment it was made. Only later, looking back after the drawing is made, are we able to reflect on and label what was happening. What I find so fascinating is not that we are working without rules, but that the drawing reveals the rules, the marks being shaped by the conditions and limits that are present.

In 2007 my life was very busy and full. My wife and I were raising a three-year-old child in a one bedroom apartment on 42nd Street in New York City, she was pregnant with our second child, I was working furiously on a solo exhibition to be held on 57th Street at Gering & López Gallery that fall, and after living in the city for twenty years, we were renting a car on the weekends to house-hunt upstate so we could move the family and studio to a bigger space. When I sat every day in my studio and improvised, the many varied parts of my busy life rotating through my attention did not become the illustrated subjects of my drawings even though they were most present for me. I did not draw pictures of my growing family or visualize my dream house. Instead, I used the growing excitement and anxiety to fuel my improvisational practice and let anything arise. I tried to be present with all that was going on and let my hand move freely. The most persistent images that arose spontaneously from that time were cubes, stacked unstably on top of each other that looked like towers about to fall over. Later, looking over those forms, I saw slouching figures, unstable skyscrapers, and tippy piles of movers' boxes.

............

7 Ram Dass, "Bringing it all Back Home," *Ram Dass Here and Now*, podcast, July 18, 2013, 00:50:17.

Drawing to Reveal Inner Conditions

To see this inner reflection in action, you can start by choosing an object, an image, an idea, or a feeling. Or just look into this moment and note anything that is present for you. Whatever is strongest or most obvious in the moment usually gives a lot of energy to work with, so use that energy if you can. Our goal is not to make a picture of that thing. Instead, we only want to hold the composite sensation of the moment in our mind as a space from which to improvise. We can't help but draw ourselves.

Take time now and improvise, making present what you can't ignore. See what marks appear in the drawing from many various objects of meditation. We are using the improvisational drawing process to look further than the eyes can see. Paul Klee adds:

> Something has been made visible which could not have been perceived without the effort to make it visible. Yes, you might see something, but you would have no exact knowledge of it. But here we are entering the realm of art; here we must be very clear about the aim of "making-visible." Are we merely noting things seen in order to remember them or are we also trying to reveal what is not visible? Once we know and feel this distinction, we have come to the fundamental point of artistic creation.[8]

............

8 Paul Klee, *Notebooks Volume 1: The Thinking Eye*, trans. Ralph Manheim (London: Lund Humphries Publishers, Ltd., 1961), 454.

The Frame Underlying the Frame
02.14.2009

Making marks matter

Why is "making-visible" important and how is it different from meditation or imagination? If the contemplative-drawing process is focused on introspection and the marks on paper are secondary, why do I have to actually make a drawing and not just think of one? Does something change when I put pencil to paper? The answer is yes, many things change when a drawing is made—in the mind, in the physical world, and in the relationship between the two. We encode ourselves in our drawings, and the choices we make about what and how to draw are only revealed when we have results to contemplate.

When a desire to draw is transferred to marks on a page and a drawing comes into being, the intelligence that initiated the action must next cope with the representation on paper. How do I reconcile the difference between what I feel and the way the drawing looks? To begin with, the image that forms in my mind is made of the same stuff as my thoughts and emotions, inextricably entangled with my memories, emotions, and instincts, which collaborate to filter and help decide what occupies my attention. When I make a drawing, I am transferring some small aspect of that neural soup onto paper; the resulting image can't contain everything that was part of my dynamic thought form. The drawing is necessarily a reduction of this much more complex process, but noting the differences between what is in my mind and what appears on paper can lead to some very instructive insights. Rather than despairing over what is lacking in the representation or feeling elated at the fidelity of the visual illusion formed, I focus instead on what has actually been created from combining graphite and paper: the thing itself.

The result of the actions of drawing, born into the physical world, is a new specimen—a thing I can touch, a countable presence, an altered scrap of material now accorded rights and social status as an artwork. How does the transition happen? I make a contour line and get the initial surprise of seeing the mark as it appears. I compare how much or how little the line resembles the object I am drawing, but there is a deeper surprise, even amusement, when I understand what

particular aspects of my vision the line corresponds to and what parts are not there. For example, imagine I set up a still life by arranging flowers in a vase, some pieces of fruit, and a jar of jam in front. Where do I start drawing? Let's say I decide to start by outlining the profile of the jar lid. The line I make to represent the lid may indicate which part of the jar stuck out the most or seemed easiest to draw, but maybe a sudden memory of my mother's fig preserves made me nostalgic for home canning. There are multiple possible meanings, some operating simultaneously, that can be assigned to a single contour, and I would need to look inward to discern the exact nature of the motivation. But without having made the mark on paper, this finer discernment can't take place because I am not able to imagine what mark will finally appear and how the marks will look until they are made—without the mark on paper there is no feedback.

Like the paradox of Schrödinger's cat, the mark may be alive or dead, good or bad, and we can't know until we lift the lid—the "truth" behind the mark can't be read until there is a mark to read, separating all possible marks from *this* mark. Without an external mark there is no mirror to my internal state. When I ask myself how I feel about the drawing of the jar lid, I regret that my rendering was unable to transfer to me the taste of the figs inside the jar or uncover the warm feelings I had when receiving my favorite fruit preserve in a care package from my mother. By turning around the experience of looking—by deducing my internal state from the marks I've made—I have a clearer sense of why I was attracted to drawing the jar initially. The line reveals to me the feelings and attachments I most closely associate with the object. Hidden feelings and desires can be encoded and recognized in an object if I take the time to make the lines on paper and investigate them.

How does making a drawing change the physical world? When a pencil moves across paper, it leaves a trail of carbon atoms. I take action and get satisfyingly immediate feedback. Unlike my imagination, the marks don't fly away as soon as I change my mind. The symbols drawn on the page are a kind of external memory, but the piece of paper itself, its physical qualities, are equally important. This new thing in the world has presence, size, and weight, can be kept or discarded, and

is a record of the moment it was created. The idea represented on the page can be scanned, copied, or given away, but the paper remains in my possession. Our drawings release the unpredictable accumulations of feelings, ideas, and desires that would never find external expression if we kept them in our head. If thoughts are fleeting, pencil on paper seems eternal, by comparison.

Another reason that making marks on paper matters is the positive feedback loop from mind to paper and back to mind. If putting down an idea reduces it, taking it back into the mind as both symbol and object enlarges it in a new way. The improvisational practice exists in this feedback space—generating spontaneous marks, seeing their effect, and generating again and again until some structure develops and some attractors emerge. Improvisational drawing asks us to work with the feeling and not the vision, to try to let loose and encode our present moment into the marks, unconcerned with rendering, then to react to those marks and continue to discover what comes up. It is through externalizing and reabsorbing the creative energy that this style of contemplative practice gains momentum.

Even if we agree that making a work on paper is necessary, that imagination alone isn't enough to produce feedback, I often find it difficult to start working. If I ask myself to choose an object to draw, I become very self-analytical about the meaning. Why did I choose to draw a picture of a lotus? Or a skyscraper? Or a cloud? I try to guess the meaning before the drawing has started, avoiding certain objects, even though the meanings arise as much from the shape of the line as from the subject. In the next practice we don't choose an object to draw, instead we look inward at the process of choosing.

Noticing Intuition

Let's continue to practice improvisational drawing by further letting go. This time we don't hold an object or feeling in our mind but instead turn our attention toward observing the discerning mind in action, trying to witness our own intuitive process.

We take as a basic instruction the words of the Diamond Sutra: "Let the mind arise without fixing it anywhere," and allow any thoughts to appear and pass away without trying to *do* anything. Sitting quietly, eyes shut, in this state of self-observation, the mind will naturally settle down. Allow it to happen—thought after thought passing by.

In this state of open awareness, as in the last practice, slowly open your eyes, pick up a pencil, and let your hand move. Each time a new line appears, pay close attention to any feelings, harmony or discord, balance or imbalance, and simplicity or complexity—not judgments but small nudges, often in the heart or gut—that summarize a sense of what is appearing. Can you refrain from judgment—liking or disliking—and give more attention to just observing and giving space to the feelings that seem to automatically guide the process? Try to isolate and observe the sense of incompleteness that compels you to keep adding lines one after the other, as well as the sense of completeness that tells you to change what you are doing or to stop drawing.

We are noticing taste: an intuitive sense of what resonates, a sense beyond like and dislike, a sense of rightness, of completeness, a certainty about the way things should be. If it is difficult to talk and write about how to improvise, this is because it is equally difficult to describe intuition. How do we describe what is beautiful, what looks right, and what looks interesting? Our taste is so ingrained once we reach adulthood that we aren't usually aware of how we know when a room is clean and in order, when the furniture is arranged in the right place, where a picture should be hung, or how we prefer dishes to be arranged in a

cupboard, but we know immediately when things are out of place. How do you know what food you love to eat? How do you know which people attract you?

Sitting and watching a drawing appear mark by mark, you may pass through many thoughts and feelings, showing you the flighty and context-sensitive nature of taste. Cultivating personal taste requires getting in tune with joy and following the most resonant option. Moving through the work by making choices based on this internal balance, always asking what is right, is the same kind of discernment needed when handling relationships, conducting business, and in general deciding how to live a good life.

Keep drawing and amplify what resonates for you.

Finding an ending

The only way to end a chapter on improvisation is to ask, "How do I know when a drawing is done?" This question has as many answers as there are drawings. Let's see if there are some broad boundaries to help us judge the degree of doneness. If you are having fun letting out your inner child on the page and stopping doesn't feel like an option, then I say let it roll—a thickly layered drawing can be compelling and rich. But be cautious, and pay attention to your intention when your lines begin to overwrite as much as you create.

Besides looking at the object in front of you for completeness, it is a good idea to check your own state of mind and energy level. You may find yourself annoyed at the lines and shapes that are appearing, thinking of them as ugly scribbles. That annoyance may signal a time to stop, but maybe not, if the energy of the scribbled lines is working for you. If you come to a sense of balance (or of interesting imbalance) and you find yourself fascinated with what you've created, step back. If your mind is telling stories about the image, or you are falling into self-congratulation, it is a good time to pause because your attention has wandered. Gently return your thoughts to allowing the hand to move freely. If you are too cautious, you may never come to a breakthrough; act too boldly and delicate connections may be lost. Knowing when a drawing is done comes from experience. I have overworked way too many drawings because I can't leave well enough alone, unwilling to accept an open-ended state of completion.

Paul Klee advises us to work freely but not without finding an ending: "We should not hesitate to follow our bent, but when it comes to the result, in the absolute sense, that is, there has to be a solution. If a picture is good, one must be inwardly satisfied even if one disregards what it represents."[9] In Klee's mind, the subject is secondary to an undefined inner satisfaction. The French author and poet Paul Valéry also touches on satisfaction, raising questions about judging a work and asking if creative work ever really ends: "A work is never completed except by some accident such as weariness, satisfaction, the need to deliver, or death: for, in

.............

9 Ibid., 461.

relation to who or what is making it, it can only be one stage in a series of inner transformations."[10]

I understand from Valéry that even my own satisfaction is not an endpoint and each work is only a stage in my growth as an artist.

Growing Awareness
01.02.2011

..............

10 Paul Valéry, *Collected Works of Paul Valery, Volume. 1: Poems*, (Princeton: Princeton University Press, 2015), xvi-xvii.

You are the Universe Drawing

The most general instruction for improvisational drawing is "just draw." No need to say more. Our everyday physical and mental conditions are the limits within which we improvise our lives. When I mindfully let go, drawings emerge. You can use this practice as a powerful vehicle to know yourself.

But there is another territory to visit, an orthogonal axis to explore, a way to turn the view away from our lives and look deeper into the source of our creativity. Instead of improvising by noticing and reacting to our limits, in this practice we get out of the way entirely, imagining that we are serving as a channel for the forces responsible for creating and holding the universe together. In this improvisation, we imagine ourselves without free will, in service of these unnamed universal forces.

To open yourself and allow these forces to be in charge, first sit in silent meditation for a short while, relaxing and slowly drawing your attention back to "this," the place where we are, this moment, here, and now.

Imagine the Big Bang, when the material universe sprang into being and created all the energy and matter, all the atoms that have been recombining, gaining complexity, and evolving into life. Picture the countless stars that were the source of all the elements on Earth. Thinking about the atoms in our bodies, how we are made of the primordial energy, can you appreciate how we are inseparable from the universe? We are made of the same stuff. Our planet and all living things have emerged entirely from within and as part of the flow of this huge ongoing process. Feel how inseparable your life is from the universe and ask yourself, what does it mean that I am awake, that I am aware of this moment in the ongoing process? Does it mean that the larger process is also awake? Yes, it is awake because we are awake and not separate from it. Imagine that through us—through each mind acting like a cell in the universal body—our practice serves as a channel through which the process knows itself. When we draw and observe the result, we play our role in how the system changes.

Sitting quietly in this view, draw freely and imagine that whatever you are motivated to draw is the only result that the system can produce. You are the awake representative of the flow, feeding your sensory-filtered view back into the continuum. This life, this moment in time, exists for the mark being made, for the universe to draw as you.

The last section of this chapter is a case study of improvisation and contemplative drawing. The text is taken from my online daily drawing journal (http://iclock. com), and recounts a weekend I spent in isolation, trying to discern for the first time the connections between what I felt and what I drew. If you haven't yet made this connection, I hope to give you some inspiration to undertake a study where you may catch a glimpse of the shifting nature of the creative path and gain the unexpected fruit of sustained effort.

The way I feel inside about what I see changes when I try to realize that vision

Tonight as I was trying to settle down and meditate, I remembered the story of how my body and mind converged in drawing for the first time. It was 1992, I had finished my MFA degree, and I was teaching computer art at the School of Visual Arts in Manhattan, while continuing to study and develop my own work. Since I was allowed to take classes for free at the school outside of my department, I signed up for a drawing class in the Fine Arts Department, where I quickly found myself struggling—not with my technique, but with the disquieting feeling that I didn't know why I was making a drawing in the first place. I felt like I had a lot to say, and I certainly had a lot of creative energy, but I was never able to reconcile the marks on paper with the feeling I wanted to transmit.

As usual, I had too many ideas, too many things to try, and too many reasons. My drawings looked interesting but why did they feel lifeless? I could always find a note but never a whole chord. Where was the resonance?

After conducting a series of self-directed experiments in drawing class, such as drawing everything with straight lines, applying graphite so thick the powder drifted off the page and down onto the floor, and making random charcoal smudges that I then scratched away with a key, my drawing teacher picked up on my desperation and we had a little talk.

This was her advice: "If you want to 'get it,' lock yourself in your studio and draw nonstop for three days."

Surprisingly, I found I was ready to undertake such a journey; she had given me permission to let go entirely and indulge an impulse I would never have imagined I would come to love so much. I left work early the next Friday, the start of a three-day weekend, picked up a falafel sandwich, went back to my apartment, and began to draw.

I was living in a one bedroom on East 88th Street, and my studio was a tiny closet just off the kitchen—less than one hundred square feet—with no windows; my drawing table and a pile of maps just barely fit inside. When I finished my master's degree in Earth and Planetary Science from Washington University in St. Louis and moved to New York City, I had brought along several hundred decommissioned U.S. Geological Survey topographic maps, which I regarded as large sheets of free archival drawing paper. I liked drawing on top of the maps although I didn't know why; maybe it felt rebellious, or environmentally friendly to reuse maps of the earth, or interesting to draw on such a busy ground. Whatever the reason, most of my drawing in those days was done on maps.

I ate my sandwich and started drawing, working until about midnight, when I crashed. I was pushing an oil stick around the maps and making a mess. I got up early on Saturday morning, poured myself some coffee, took out a pencil, sat in a chair, and began some detailed doodling.

I sat there, completely absorbed, sunshine and blue sky turning unexpectedly stormy, sheets of rain on the bedroom window justifying my choice to stay put, and indulged myself in the lavish practice of dissolving Schmincke extra-soft artists' pastels into the water I pooled on the maps. I only concerned myself with the density of the pigment and how pronounced I left the lines.

In seeing my concern with articulated lines, my teacher once directed me to study van Gogh's pen and ink drawings of flowers and gardens, knowing I would notice how his marks were simultaneously depictions of flowers and maps of the physical space. I'm sure that somewhere in this three-day experiment those

observations came back to me, and my diagrammatic compositional style was born. I felt van Gogh's affinity for mapping the natural order of the French countryside and used this to guide the mapping of my own interior spaces.

The rest of that rainy Saturday was spent developing ideas about diagrammatic composition, noting that a map was readable both informationally and pictorially and that one's mind transitioned between the two readings, hardly able to hold both together. I wanted to make drawings that were conscious of both ways of reading. It was a slog to keep inventing visual devices because most didn't work well, but I managed to stick with the task all afternoon. Saturday night, I had sushi delivered for dinner.

With a day and an evening already under my belt, I arose early Sunday morning, taking only coffee and half a sesame bagel that was left in the fridge, and sat at the drawing table in my boxers, energized by my dedication to the project. With a brand new piece of bright white five-dollar drawing paper, clean brush in hand, and fresh dish of water at my side, I poured out a measure of heavily pigmented black ink and divided the page into rows and columns of squares, each one to be filled with a unique composition.

I was unaware of the weather that Sunday afternoon, not eating, not leaving my table, exhausting all my ideas for compositions, panicking about what to draw, making random marks for the sake of sticking to the plan, pausing to listen and receive in the silence, grasping for an idea and finding nothing, no creative energy, empty for the longest time, resting, and then slowly, as the day faded through the arising and passing away, I glimpsed every side of myself at once. Resting in the ebb and flow.

During that night, marks and brush strokes flowed past my eyes, clean sheets of paper replaced filled ones, and what came into being was what had to exist; an expression of the natural state. I don't know how long I drew, late that Sunday or well into Monday morning—maybe I'm still there drawing. Since then, I've never stopped allowing the drawings to arise and have done my best to put them on paper.

That Monday when I finally got out of bed, still committed to the project, I reviewed drawings from the night before. Sipping coffee, knowing this was the last

day, recalling my blissfully open state of mind, the ease of allowing, new in the light of day, I sat and resumed dissolving pastels over maps, my work still not complete, the noises of the city waking up, a few stars left in my head. I hoped the magic survived, hoped to add one more layer of resonance, one more day of practice, one more insight to my transformation.

After lunch I felt pressured. The anxiety of returning to my job the next day and having to leave the solitude of the studio made me desperate for a breakthrough; but dinnertime came and went and I was worn out. Then in the waning minutes of my project, ready for sleep, ending my studio vigil and sitting one last time to look through the weekend's production, I saw through the veil.

Flipping through stacks of drawings, not focused on any part of the drawing and too tired to think, just sitting, just looking, just feeling the visual texture of the materials—the slightly toothy texture of the paper infused with streaks of pastel pigment, fine grains sticking out of the surface of the paper—I felt these objects transmit back to me the residual energy of my three-day immersion. Without identifying landscapes or faces, naming or judging, only feeling aesthetic pleasure and the newness of something previously unseen now in my possession, I laid one singular item slowly on top of the other, open to what sensations they stirred.

It happened the moment after my eyes scanned a piece of map that had the words "sand pit" printed on it. The meaning of the text entered my mind just as I focused on a smeared clump of sandy yellow ochre pigment and in my mind the words were overlaid on the paint. I immediately grasped the correspondence, the simultaneous reality, between words and materials.

I understood the resonance between text and textures—that pigment was sand, while simultaneously representing sand in the drawing. The possibilities for interplay of signified and signifier, and material and meaning were endless, and with this insight my art found what it didn't know it needed: a pathway through which to meaningfully enter the physical world. In this case, the map *was* the territory. If studied closely, this moment contained all the elements essential to my life and my art: improvisational approach, diagrammatic view, systematic path, and resonant simultaneity.

One Point
08.22.2009

5
READING THE DRAWINGS

Reading your drawings is a great way to get to know yourself better. You don't have to *explain* the drawings or give them labels like "landscape" or "abstract." Rather, you can try to open the space around the personal meanings layered inside. Start by listing a drawing's physical qualities, such as the size and texture of the paper, the type of pencil, and the style of marks. Second, share how the drawing makes you feel, describing any emotions that arise. Next, you can analyze the subject matter, telling yourself stories about the objects or symbols you drew. Finally, try to connect to the wisdom your drawing contains. This sequence corresponds roughly with the Buddhist teachings about the Four Foundations of Mindfulness: body, feelings, mind, and *dharmas*.

In this chapter, I introduce four techniques for "reading" drawings. It is important to finish all four practices: looking at your drawing from these different viewpoints will show you more clearly who is doing the drawing.

What the marks revealed

As described at the end of Chapter Two, I packed up my figure drawings, shipped them back to college, and left Florence. Two years later, I was moving into an off-campus apartment, hauling boxes from storage, when I came across the bulky, heavily taped portfolio made of cheap cardboard, covered in postmarks and Italian customs stamps. I remember the humidity. I was sweating while carrying boxes up and down the stairs. After supper and a conversation with my new roommate, I got around to sorting out that pile of stuff. I used one side of a pair of opened scissors to punch through the tape and delicately slice it along the edge of the portfolio. The scents of linseed oil and perfume wafted out with the stacks of papers,

triggering memories and emotions. The drawings astonished me, not because they were beautiful or had any technical excellence, but precisely because they didn't.

I didn't recognize the tentatively drawn nude figure but I did recognize my tentative drawing self. The pages were a completely honest recording of the person I was when I drew them—I could not escape knowing just who I was, how little I knew about drawing, and what I thought I was doing then. The pride, embarrassment, freedom, and stress of that time returned full force: the beginner's mistakes in shading and the nervous contour lines throwing me back in time. I was suddenly standing in a circle of easels, staring at a naked model. And just as quickly I came back to my new room, clinging to myself and understanding, by contrast, the person I had now become. For the first time I felt just how much information was imprinted by an artist in a work of art and how an artwork facilitates insight on many levels simultaneously.

Drawings are portraits of the person who makes them. When I draw I reveal myself in ways that I don't see and can't know in the creative moment. What has become very clear to me as an artist, observing my work over longer and longer periods of time, is that any meaning a work conveys, any energy that it transmits to viewers, is not primarily through what is depicted; subject and materials are secondary to the artist's condition. Having seen how my mental states were encoded in the marks of my drawings, I began seizing every opportunity to make drawings and learn more about myself. When I was twenty-two years old and impatient, I made my drawings in extremes of anger, depression, and chemically altered states because that's what felt real; I wanted to use drawing to strip away my stories and show me "who I was." Imagine a mirror that records everything, unerring but on a time delay. How would you pose in front of it?

I became fascinated with how lines could reveal information about my state of mind—information that I couldn't know while I was drawing. I hid myself away, practicing late at night on computer drawing programs that I wrote myself and on big sheets of paper hung in my apartment—gesturing wildly, throwing ink, and seeing what resulted. I asked myself what would happen to these pieces of paper in the future and what would become important about my making this drawing today, here, in this state of mind?

An Exact Physical Description

This is the first of four practices for reading the drawings. Please start by picking one of your drawings, a "good" one that you immediately respond to, something you like even if you don't know why. We'll try to find out much more about it in this chapter, so stay with the same drawing for all four practices, as they will offer four distinct ways of looking at the same piece. Be sure to write down your readings for each practice so you can compare your views at the end.

The first way to read a drawing is to look at the paper and marks for only their physical qualities: see the paper as an object, only noticing what is on the surface and not labeling any of the marks. The goal of this practice is to give a description, in written words, that details the physical shapes and arrangements of the marks. For example, you might use language like this:

> On a four-inch by six-inch piece of rectangular newsprint,
> beginning in the upper left quarter of the page, is a series of
> nonintersecting gray half-inch and mostly horizontal line seg-
> ments that lead across the center of the page. In the upper
> third are many ovals, some open and some solid red with a
> powdery texture that form a dense cluster and gradually radiate
> outward.

What we want to avoid is using labels like cup, vase, mountain, face, etc., to describe what you see; in other words, for this practice, don't write, "a drawing of a cat." Only note the materials without assigning meaning. Articulate the color, position, textures, shapes, and other physical attributes of the marks that fill the page. Notice what it feels like when you focus only on the materials. How do you describe irregular shapes? Are you including variations in thickness, roughness, or concentration of marks? Do you slip into calling a bifurcating line a branch because it looks like part of a tree?

Grumpy men and barren landscapes

In the early 1990s I was spending long hours in daily drawing sessions, test-driving my new digital tools to discover all the things they could do. My motto was "Keep making drawings until I see a way to expand the tool's features." Then I'd return to the code editor, add a variation to the brush, and begin testing it again. And so I sat at the tables in the School of Visual Art's computer lab where I taught (almost no one had a computer at home then, and there were no laptops), eyes drying out from staring at the bright CRT, making drawing after drawing on the screen.

This style of working, half testing code and half creating images, gave me the first inkling of what could arise when there was no pressure for a drawing to be "about" something or look like anything. My goal was tool testing so I was unattached to the outcome—I only kept the drawings as examples of the tool's function. When I took up my pressure-sensitive drawing stylus after creating a new tool variation I was always excited. I never knew exactly what would happen, so I was always drawing lines with a sense of discovery and surprise, rather than with control and previsualization. Even if the code executed perfectly, I couldn't predict how the line would look when I drew at different speeds or varied the pressure. Many times the brush tool was a technical failure, such as an error in logic or math that caused the tool to draw in some unplanned way; many times these "failures" became new brushes in a class by themselves. I kept a very open mind as to what I was seeing, trying not to judge the outcome right away but learn to appreciate the code for the interesting chaos it could create.

More important than my fascination with the tool's novelty was that sometimes the random test marks and scribbles would suggest imagery—I'd start to recognize things in the drawing. My spinning line tool made marks that looked to me like fences half covered by sand. Another animated brush looked like bird's wings flapping out a decorative trail. One hatch tool variation drew spines; another cactuses. The resemblances were my shorthand names for the tool variations.

As the tools made more interesting and varied marks, I used them for longer periods of time, and then even more complex and identifiable forms emerged.

Among the first things I recognized were faces—not surprising since our brains are wired to see faces especially well—but these were distorted and unhappy faces. I felt like I was discovering "my style" and accepted it, which led me to seek out the art history of unusual portraiture like Rembrandt's etchings of elderly women and men (including himself). I attempted to make printouts of the on-screen drawings in a way that resembled traditional etching by making laser prints of the heads on fine paper with embossing. I was so very busy doing the things that looked like what an artist did that I never stopped to look inward and ask *why* I saw those combinations of marks as faces—disgruntled faces, male faces—and what that unhappy mood was all about. After all, this was "my thing" and that's "the kind of artist I was"—or so I reasoned. Then, after I had gotten comfortable with my self-image as a portraitist, having drawn hundreds of grumpy faces, a bare horizon line, a kind of dystopian landscape for the face to live in, began showing up, and occasionally on that line sat a freshly cut tree stump.

Obvious and hidden meanings

For many years as a teenager growing up in central Louisiana, I went on monthly campouts with my Boy Scout troop. I remember fondly the time I spent in the woods, stoking fires with big heaps of pine straw, throwing knives, fishing, backpacking, catching snakes, and swimming in lakes. The local scout camp was my summer home. Nestled in a pine forest, it felt miles from civilization, absolutely quiet at night except for the occasional train whistle in the distance. But it wasn't all so idyllic—the land surrounding the camp was owned by a forestry company. The last summer that I worked there, as I drove toward the camp, I was startled when I didn't recognize the turnoff, seeing an open field instead of the beautiful trees I was so used to. I felt sick to my stomach—the pine forest had been clear-cut. Except for a small perimeter of trees around the camp, I looked out on a vast open stretch of land with only a few stumps remaining.

When tree stumps began appearing in my newly improvised software drawings,

I immediately identified the loss of my pine forest experience as the emotional driving force. Clearly, my subconscious was not settled about the issue and needed a voice. This art was political—against deforestation, against capitalist greed, against those who would destroy precious woods that held so much life and sentimental attachment. I kept drawing those tree stumps and grumpy faces with full confidence in their inner meaning. I was an environmental artist! I had found my calling—but there was more of the story to come. The truth of those drawings was not as simple as I thought.

Mardi Gras

Life growing up in the warm climate of Louisiana can be exciting and delicious if your family knows how to have fun. My mother's family in New Orleans knew how to have a good time: fancy restaurants, tall drinks, and music. Our family never missed a Mardi Gras parade. There is also an edge to the city, something in the spirit of the place that gives it a mysterious feel, like the clouds that gather there on summer afternoons turning the sky black before unleashing a thunderstorm. The best and worst moments of my life have happened in New Orleans.

Of all the people in my family who I loved and looked up to, in whose company so many early memories were formed, there was one, my cousin Dennery, who was my heart companion—that kind of person for whom you feel something deeper than love, the kind of person you always want to be with. She was older than I was and a practicing artist who made ceramic jewelry and meticulously crafted abstract sculptures out of painted wood. When the moment came in my life to finally break away from a career in the sciences and declare I was an artist, Dennery's established art practice had already made the transition acceptable in my family. She and her wonderful husband, Steve, also an artist, lived in New Orleans, which only amplified my attraction to the city, and I visited them regularly.

During that time she developed breakthrough work by incorporating Mardi Gras symbols and colors, a move that brought so much hometown imagery into

her work. It was fresh and individual so it no longer reflected her formal art school training or even art history. Dennery saw what was obvious and interesting about Mardi Gras and distilled it into novel but also familiar symbols such as her take on the *boeuf gras* (the fatted calf, a symbol of carnival) and the classic Venetian *Colombina*, or half-mask; the sculptures themselves were set on tiny wheels, as if they were parade floats. Her artwork pushed me to go further inside, to discover what I loved, what I found true, and to bring it out and celebrate.

I remember so clearly the morning the call came: I was working in New York City during Mardi Gras that year, saving my vacation days for JazzFest in May. I came into the office and my father was on the phone. He said I should sit down. I knew that my grandmother was almost ninety and was not in good health, so I had been expecting this call. But my grandmother was okay—it was my cousin Dennery who had collapsed and stopped breathing. The traffic was so thick in the chaos after a parade that the ambulance was late. At age thirty-three, she died.

A year later I started drawing those grumpy men and tree stumps. I told everyone who looked at the drawings the story of my Boy Scout days and shared my anger with the logging companies, how wrong clear-cutting was, and all the bad environmental effects of deforestation. I became fully invested in this story, sticking to drawing tree stumps as some kind of proof of my commitment. I believed this story until one day another story occurred to me, a realization I couldn't deny. The men weren't grumpy about pulpwood—they were symbols of my grief over the loss of my cousin, and the tree stump symbolized her life cut short.

I could have continued drawing grumpy heads, barren landscapes, and tree stumps, stubbornly sticking to my style, but the drawings and my new reading had released some deep feelings and helped me cope with them. The truth is that the story of the images as symbols of my grief shook me deeper than the story about trees. If readings are able to displace one another, I wondered, how many other stories might coexist in this one image? How many ways are there to read a drawing? How do I decide what it is really about?

My emotions answered these questions for me. I remember sitting there, feeling certain that the connection of the drawings to my cousin was real even if I

Hidden Meaning
05.30.1992

couldn't articulate how the images had come up. As the truth of the new story sunk in I thought I heard a faint sound, like a stone falling into a deep ravine, bouncing off the walls as it went, sending back ever-fainter echoes. The truth reverberated inside me.

I never made a conscious decision to stop drawing grumpy heads and tree stumps. The images and their stories were part of my grieving process, and after my insight I felt lighter and became more playful with my animated drawing

tools. Soon new figures started to appear; my imagination began to identify new forms in the improvised marks and eventually told new stories. My commitment to the deforestation story had given me the discipline to continue drawing late at night, a practice that facilitated subconscious—or even unconscious—grieving. Recognizing how my emotions and unconscious mind were arranging my life to give me what I needed, even shaping the images to tell the story, showed me that there was a deeper process at work. Drawing is the mirror through which I divined these connections and saw these hidden things—it was my vehicle for healing and growth. The drawings remain with me, kept as pen plotter ink drawings on paper and in digital files. The process worked for me. The beauty of the system is the beauty of the drawings.

I worked through this grief more than twenty years ago, but sitting here near midnight in the summer of 2015 at my kitchen table and writing this to you on my iPad, I am feeling sadness again. I hear another bounce of that faint echo, another stage of releasing grief, and I wonder just how far down that ravine goes—and how my feelings will change when this memory travels from my heart and mind to yours.

Feeling the Meaning

The second way to read a drawing is to get in touch with and articulate the feelings your chosen drawing elicits in you. In this case, the subject of the drawing is secondary to the emotions it evokes; if a drawing of a cat triggers warmth and attraction but also longing, you should note all of those, focusing on the feelings rather than the cat.

Do different colors make you feel different? Look at a variety of paintings in a museum or a book and try to track your inner responses. An abstract painting like Wassily Kandinsky's *Sky Blue*, whose bright figures floating on a soft cerulean ground hit me with joy and levity when I first saw it, but also gave me the feeling of a sudden urge to run to my studio and create. Compare versions of Monet's haystacks while tuned into the states of emotion that are aroused by the various palettes. Seek out an image of Edvard Munch's *The Scream* or Picasso's *Guernica*—two examples of works that depict obvious angst—sit with them, and see if sentiments get triggered.

For some people being in touch with emerging feelings is not so easy. During my workshops, tensions seem to peak with this practice when we are called upon to read and share our emotions. Turning toward feelings makes everyone vulnerable; there is a real fear that the process will cascade and long-avoided sentiments will come up, causing emotional pain.

If you experience discomfort, please go slowly. Take a break if your emotions become overwhelming. Find courage in the knowledge that there is often a lot to be learned in the places where you find resistance. Focus on awareness of feelings and get ready to write things down.

Return to the drawing you chose for Practice Twenty-Three. Sit with it for a few minutes, not describing the drawing or what it looks like, but simply noting and, if possible, writing down your feelings. Even if a feeling that comes up doesn't seem to relate at all to the supposed subject of the drawing, record it faithfully—it's telling you something.

Why the brain tells stories

What can modern science tell us about why we make up stories? We know that language comprehension, word formation, and speech production are located primarily in one hemisphere while areas related to visual thinking are often, although not exclusively, in the opposite hemisphere. Dr. Michael Gazzaniga, a leading researcher in cognitive neuroscience, studies how the brain communicates with itself, particularly through his extensive experiments with people whose brain hemispheres are separated. By focusing on the verbal and visual functions that are kept apart in a split brain, Dr. Gazzaniga and his colleagues have found important insights into how we coordinate our thoughts when associating seeing and speaking.

One of Dr. Gazzaniga's best-known experiments further illustrates our brain's amazing capacity to fill in perceptual gaps by making up stories. This work convinced me that drawing and telling stories about drawing was a real path to self-knowledge:

> We showed a split-brain patient two pictures: To his right visual field, a chicken claw, so the left hemisphere saw only the claw picture, and to the left visual field, a snow scene, so the right hemisphere saw only that. He was then asked to choose a picture from an array placed in full view in front of him, which both hemispheres could see. His left hand pointed to a shovel (which was the most appropriate answer for the snow scene) and his right hand pointed to a chicken (the most appropriate answer for the chicken claw).
>
> We asked why he chose those items. His left-hemisphere speech center replied, "Oh, that's simple. The chicken claw goes with the chicken," easily explaining what it knew. It had seen the chicken claw. Then, looking down at his left hand pointing to the shovel,

without missing a beat, he said, "And you need a shovel to clean out the chicken shed." Immediately, the left brain, observing the left hand's response without the knowledge of why it had picked that item, put it into a context that would explain it. It knew nothing about the snow scene, but it had to explain the shovel in front of his left hand. Well, chickens do make a mess, and you have to clean it up. Ah, that's it! Makes sense.

What was interesting was that the left hemisphere did not say, "I don't know," which was the correct answer. It made up a post hoc answer that fit the situation. It confabulated, taking cues from what it knew and putting them together in an answer that made sense.

We called this left-hemisphere process the interpreterit is the left hemisphere that engages in the human tendency to find order in chaos, that tries to fit everything into a story and put it into a context. It seems driven to hypothesize about the structure of the world even in the face of evidence that no pattern exists.[1]

We all confabulate. When tragedy strikes, we want narratives to explain why it happened. When scientists try to put together conflicting data, they theorize. I attempt to reconcile disparate facts by concocting plausible scenarios—making up stories about drawings for my art collectors because, after all, what art patron doesn't like to know the real story behind an artwork?

1 Michael S. Gazzaniga, *Who's in Charge?: Free Will and the Science of the Brain* (New York: HarperCollins, 2011), 69–70, 72.

The Story We Tell Ourselves

When I tease my mother by pretending to have heard some outlandish gossip, she gives me one of her frown-smiles and says, "You're just making shit up." And yeah, I am just making up stories, but really, how else do I talk about things? When I'm in conversation I don't have a script but the words seem to appear as I'm saying them. How does that work?

Return again to the drawing you chose for the previous two practices. This time, make up a story about the drawing. Describe the subject, what the drawing symbolizes, and what each part means. Why did you draw it? What memories are associated with it? If your story is a narrative, write down the parts before, during, and after the scene depicted. If it is a metaphor, explain the meaning. What is that drawing all about? Give us the full story.

Cycles in Motion
11.27.2009

A figure-ground reversal and the no-self portrait

If my mind seems to always make up stories, what do those stories say about who I am and how I see the world? Does consciously shifting my view change how I describe myself? How responsible am I for the content and direction of my story? What if I am not telling a story but a story is telling me? If I am open to listening, are there things to be learned from the images?

I want to tell you one last story about my improvisational drawing practice that tries to explain what is really happening when my mind is busy making things

up. I noticed after several years that certain symbols like spiral vortices, unfolding objects, and tippy towers would appear over and over again in my daily drawings. I gave attention to the shapes that were stubborn and kept appearing. If I was able to make up an insightful story about the persistent symbol, I studied the symbol in detail and kept the stories going to see where they ended. Sticking with persistent imagery felt right, and reminded me of something the Buddhist nun and great teacher Pema Chödrön once said regarding our own suffering: "Nothing ever goes away until it has taught us what we need to know."[2]

In my experience, when my stories change, the persistent images change along with them. At the end of 2008 in the midst of the global financial crisis, my art business, like that of so many others, suffered many setbacks. I had canceled orders, delayed payments, and diminishing prospects for new sales during the recession; I struggled with cash flow and worried about maintaining my business and home. The most prominent persistent symbol up to that time, the tippy towers of boxes, fell over and curled up; a new symbol, circular composite shapes made mostly of overlapping distorted rectangles, emerged as their replacement. I quickly dubbed these new forms "cycles," and their appearance suggested to me a story about the cyclical nature of life. The cycle drawings were my coping mechanism through this period of difficult financial times—they called my attention to and helped me process the impermanence of business, possessions, and life. The circular forms in the drawings encouraged me to see my experience as only part of a cycle and reassured me that good times would come around again.

As the story began to unfold in my everyday life, I believed the explanations for the drawings that I dreamed up and I loved writing and talking about what they meant. I first linked the rectangles in the cycles to the imaginary phylogons described in *The Divine Invasion* by Philip K. Dick; I wrote about the phylogons for over a year on my daily drawing site. The phylogons, I speculated, were moments in time and the river image that ran through them represented the flow of consciousness in my daily life. Next, I linked the cycles and serpentine forms to

.............

2 Pema Chödrön, *When Things Fall Apart: Heart Advice for Difficult Times* (Boston: Shambhala, 1997), 81.

the circular archetype described by Carl Jung in *Mandala Symbolism*. Jung wrote, "It is easy to see how the severe pattern imposed by a circular image of this kind compensates for the disorder and confusion of the psychic state."[3]

This seemed to fit my situation perfectly.

Although the financial crisis abated and life seemed to be opening up again, the cycles didn't disappear, and I started planning to make some of the small drawings into larger wall sculptures. I kept exploring variations of the cycles, convinced that my research and stories still beautifully explained the pictures. In that restful mental state, on September 13, 2009, almost a year after first seeing the cycles, I speculated about how many ways I had to interpret them:

> The cycle is becoming my most persistent image. Layers of meaning keep occurring to me. My most basic readings of the cycle symbol are that it represents one or more of the following: a recurring series of moments, an array of phylogons, a looping thought, unconscious self-reflection, thoughts protecting an inner meaning, an awake mind, an imperfect circle, a broken mandala.

After I had written and uploaded the drawing that night, one thought from this improvised list stuck with me: "thoughts protecting an inner meaning." After a restless night of sleep, a new idea emerged the following morning: What if articulating cycles was not the end goal of the restless energy creating them? What if the purpose in creating the cycles was only to frame or reveal the energy? What if the important part, the change I should be looking at, was taking place in the negative space that the cycles enclosed?

I made the next day's drawing as a response to this new feeling, and in the center of that drawing the outline of a human head appeared in the negative space. This figure-ground reversal, reading the negative space as positive, elicited a key insight: The thing I cling to as my "self" is only given a form by what surrounds

..............

3 C. G. Jung, *Mandala Symbolism* (Princeton: Princeton University Press, 1972), 3–4.

it—by the moments, the thoughts, and the objects that I use to identify myself. There was apparently a person in the center of the cycle, but no material was there, suggesting that "I" is created by what I surround myself with but no "I" actually exists. I called this drawing a "No-Self Portrait." This new clarity reverberated in me as I wrote: "The confluence of fragmented thought streams becomes a flood of ideas."

The cycle was no longer a cycle. The realization of the no-self seemed so profound that I was sure I was not alone in this understanding—who else understood the self as merely the construction of moments? I quickly came across Buddhist teachings on *anattā*, or no-self.

How could I have known, sitting and sketching alone in my studio, that the cycle contained a wisdom teaching? A year after the figure-ground reversal, I had

a gallery exhibition called *Innerhole* of large sculptural cycles that I made of wood and Formica. Taken from the daily drawings, the wall pieces all related in some way to the no-self portraits; the space in the center was cut away and left open to the wall. Hung on the wall, these carved wood pieces offered me another reading because it was obvious that the hole wasn't empty, it was filled with the wall—the wall was persistent and encompassed the cycle. Seen through the hole, behind the wood and surrounding the piece, the wall was a nice metaphor for consciousness underlying everything.

Figure Ground Reversal
09.14.2009

Connecting Our Story to a Larger Story

To make this fourth and final reading, return to the drawing you used in the previous three practices. This time, instead of examining physical properties, emotional responses, or analytical explanations, look for a larger story, one that connects you to your truth. Select a symbol in the drawing or see the whole drawing as a symbol that expresses something outside of you. It might be a way in which you are connected to the world around you, or you might make up a story about how the drawing is an omen of the future or a message from beyond. What does the symbol stand for? If there is a figure, which goddess or god is standing there? Pretend to be a tarot reader identifying archetypes or a fortune-teller divining. Meditate on the symbols and see deep connections. Reach for a universal meaning.

In this case, our improvisational technique has switched from drawing to journaling. Write down this story alongside the previous three readings. Looking over the four descriptions, is it easy to see how open a drawing is to interpretation? Which story do you believe the most? Do any of the ways of describing your drawing tell you more about yourself?

Alluvial Fan
12.04.2012

Today's story

After hearing all the stories I created about my work, you might be wondering what is going on in the studio today, if some image still persists. In fact, a persistent image is nearing completion. About two years ago it appeared, so I made a story about it, explored variations of the symbol, and finally came to an insight about why I was attracted to it. This book is one of the fruits of that practice.

As I began to spend more time meditating, "expansion drawings" emerged from the cycle drawings. I regularly, consciously attempted to stay open to the moment and release its energy, and what appeared on the cards were images of a picture frame being broken open by its expanding contents. What are the expansions about? At first I thought they were metaphors warning us that runaway industrial growth had exceeded the boundaries of the frame of Earth. My familiar identification as a concerned environmentalist reemerged, and I once again saw myself making symbols to save the planet. Later, looking at the drawing differently, I began telling a different story from the point of view of the expanded mass. The image was now a metaphor for the creative process: creation condensed from chaos to fit inside a small frame. That seemed even more like the kind of artist I had become. And the stories continued.

Moving forward in time, I converted some of the expansion drawings into large, digitally carved, 3-D wall reliefs. Each piece took months to produce, and when the first piece was almost finished, the entire surface painted white, I stood in front of it and gathered my wits. My plan was to finish the work by drawing directly on the face of the piece. Fully mindful of each movement, I drew with charcoal on the pristine surfaces. I improvised the way I do each day on the cards, adding energy back into the piece and bringing it to life. An image arose in my mind: as I worked the surfaces, I saw the expansion as a symbol for my own continual growth, a symbol for this newly expanding phase of my artistic and spiritual practice. I know I'm making up this story—but that is the point. Use your creative work to show you your stories, to hear what you have to say about yourself; as you begin seeing yourself in the story, you will begin to know the storyteller.

Endless Traversal
03.06.2016

6
THE SEARCH FOR THE SOURCE OF CREATIVITY

I'd like to tell you a story about how my spiritual awakening happened on a solitary vision quest, camping alone in the desert, at dawn of the third day, after sitting up all night tending a fire, the sun rising in a cloudless sky. I was seated in full lotus, focused in a deep meditative trance, perched on a red rock outcrop high above a ravine, free of responsibility, filled with compassion—and, looking up at the sky, I suddenly glimpsed the truth.

As I said, I would really like to tell you such a story but unfortunately I can't. When the disquieting feelings forming my path came to my attention, I was technically in a desert, because the city where it happened was surrounded by desert. But my revelation didn't happen in the way many people's seem to; anything resembling an awakening happened very slowly, emerging kicking and screaming from my ignorance and resistance.

It was a hot and sunny morning, and I had just left my air-conditioned hotel room to spend another day installing an art exhibition instead of making art; I was dehydrated and hungover from drinking tequila and was definitely not free of responsibility or very compassionate. As I left a food cart and took a sip of coffee, something came to me in the form of a deep, disturbing feeling; the feeling seemed to say, "This isn't what I thought it would be" or "Given my situation I should be happy; why aren't the world and my expectations matching up?" The feeling making itself known to me that morning was the culmination of years of doubt that began with an incorrect assumption I had made about my life. This feeling grew over time in proportion to the growing popularity of my artwork. Just as public attention on my work peaked, I had a crisis of confidence, doubting the origins of my ideas and becoming increasingly uncertain about what I had to say. Seeking a solid ground for my artistic motivations I asked myself, "What is an authentic

way to create? Can artwork originate as a process of self-discovery and be less concerned with market validation?" In order to answer these questions, my thinking turned more and more inward.

Early in my career I had assumed, incorrectly, that being successful as an artist would automatically equal personal happiness. Later, when I was experiencing financial reward, family acceptance, and critical praise in such large quantities, I found it difficult to disconnect from my identity as a "New York Artist" long enough to nurture my creativity, to spend time making mistakes, and to give myself the freedom to discover. When I thought about my career, I felt like I had "made it" but I was often terrified of negative criticism, jealous of anyone more successful, and constantly wanting more attention. In New Mexico in 2002, for a solo exhibition of my work at the prestigious, independent art space called SITE Santa Fe, my friends, family, and art dealer were gathered from all parts of the country for what should have been a huge celebration, but somehow I found reasons to be unsettled. When art exhibitions left me with empty feelings, I thought I only needed to move on to other shows and sell more work, and then I would be more satisfied. But I couldn't suppress the nagging feeling that by jumping easily between recognizable art historical references and dynamically changing computer graphics, I was only playing to the gallery while some deeper connection to the source of the joy eluded me. I now understand that this unsettling feeling, the curiosity about what else life could be, and the search for something more meaningful in work are often the first steps on a contemplative path.

The insight and contentment that I had assumed would come to me from intellectual study or career success came to me in the studio, from drawing and meditation. I knew all along that I found great joy in drawing but it took time and trust to move my attention away from market-driven decision-making and to be open to the broader practice of identifying, understanding, and loving my creative process as an end in itself. Until that time my creative strategy was to update popular and recognizable brands from twentieth-century Modernism, such as Mondrian's *Broadway Boogie Woogie*, by converting them into twenty-first-century art appliances, my activated software simulations displayed on wall-mounted

computer screens. I employed Mondrian's red, yellow, blue, and black squares to mimic the start and stop motion of cars at intersections in the moving traffic patterns at the heart of *ComplexCity* (2000), my most popular piece. But was making art just about finding the most popular solution? How was I deciding to activate one cultural symbol over another? Was there more meaning to be discovered behind the decision? And who was doing the deciding? I had begun my daily drawing practice as research for a creative Artificial Intelligence, but in 2002 I began using the introspective aspect of the practice to search for the source of my creative decisions. I started looking deeper into each of the choices I made during drawing, trying to discern their origin and discover who was in control.

Crossroads
02.05.2010

Priming the Source

Before a pencil mark can be made on a page, my hand must move. Hand movement depends on muscles contracting in response to signals sent from my brain. Even a thoughtless impulse to draw arises from volition triggered by stories about what art is, what artists do every day, the search for meaning, or myriad desires too numerous and interconnected to name. The deeper I look into how I decided to make a mark, the more influences I find that seem to be involved in the process.

Try this improvisational drawing exercise as a way of looking back at this dynamic source in action. Spend a few minutes getting settled in the place where you draw, paper in front of you, pencil in hand; then just sit and look into the whiteness of the paper; thoughts quieting down, breathing steady. When you feel ready to do something, set an intention to make a mark on the page, allowing any line or shape to appear. As soon as you see the mark, without thinking about it, make another mark in reaction and another reacting to that. Repeat until the process is automatic. Pay less attention to each mark and more to the relationships between subsequent marks as patterns begin to emerge. As the process continues, drop in these questions: How is the next mark being decided? From what source are these marks coming? Who's making the rules?

Finding a map

Why do we need maps of creativity? How will they help make art? Can they help my meditation practice? Such a map could enhance my flow and reduce my anxiety by preparing me for the changes ahead. Knowing there is a map makes small boring steps easier—maps are overviews, images of the whole path, and they give me a sense of progress even if ultimately each local destination is subsumed into the broader view. Maps also give me a way of managing expectations by showing me how the end of one cycle is the beginning of another. Traveling the artistic or contemplative path with a map relieves any worry about getting lost, and I can pay more attention to what I encounter along the way, watching each phase open, and welcoming the changes.

In order to discover where my art originated, I began a trek into the interior of my mind, a heroic journey to the source of creativity. Unlike mountaineers or river explorers, my inward journey was not destined to become an oft-told legend of the self-explorer's club or a favorite story among mindful adventurers recounting perilous falls, thick frustration, or ferocious animals. I did not arrive, after months of hacking through a tangle of concepts, at the shore of a clear mountain lake on a high plateau or in some identifiable region of my brain that I could point to and say, "This is it! All my ideas come from here!"

Instead of becoming famous for discovering the source of creativity, I got lost—really, really lost. I panicked, steadied myself, and searched for a map. The emergence of the internet, so taken for granted now, was the exact tool at the perfect moment for me to discover the territories of creativity and meditation. When I was in high school, independent research meant wandering up and down the stacks of local used book stores, scouring for rare editions, and hoping to discover new authors. The book title retrieved from a 1970s-era library card catalog can be laughingly compared to the data from a single Google search. We now expect our online searches to return not only published books, recent articles, and a variety of images, but also video tutorials, third-party commentaries, websites filled with forbidden, out-of print materials, and even direct contact with authors through social media.

My first objective was to uncover kindred spirits. Who else was trying to identify the sources of how we create? I found medical doctors who were using brain scans to describe the neurobiology of creative thinking and anthropologists speculating about why humans have always made and decorated objects. I spent several years trying to gather and organize a wide swath of opinions about how new ideas originate. I listened to podcasts from experts lecturing on innovation in R&D (Research and Development) departments at major corporations, practiced manifestation rituals using chaos magick, studied the mystery of creativity hidden in the tarot's major arcana, learned about mind priming in neuro-linguistic programming, envied the siddhas in Patanjali's Yoga Sutras, read cultural and religious creation stories, and followed any other leads that tried to explain creativity. I found such a variety of theories, testaments, and myths about the origins of creativity that I soon needed a meta-map to navigate all the maps.

River Whose Source Is Itself
01.07.2010

Sitting Still at the Origin

This is a meditation exercise, so take time to arrange a comfortable sitting position, and spend a few minutes quietly, allowing thoughts to settle and following your breath. When you feel ready, set an intention to visualize each moment arising.

How does the moment become known? Try and adopt an attitude of curiosity. Ask yourself, "What does this moment look like?" Do moments have different qualities such as color, shape, size, feeling tone, or thoughts attached? Can you visualize a place from which the moment arises? Where is it located, in your body, mind, or elsewhere? You may feel the moment arising before there are any labels or words. Watching the moments come and go, can you visualize the movement? Can you trace the shifts you are experiencing as a circular form, always returning? Without manipulating your experience or indulging in thoughts, allow whatever comes and observe each moment as a unique formation.

Artists are heroes!

The way I tell the story of my journey to the source of creativity sounds dramatic because the map that corresponds closely to my feelings about working in the studio comes from Joseph Campbell's deconstruction of the epic story structure, the "hero's journey." Campbell's analysis was my first meta-map or overview of the stages of creative development. If I could see the process from afar, I reasoned, I might discern the common threads in all these widely disparate approaches.

In a hero's journey, art making is a struggle, a fight for a prize, giving art production a well-defined goal. Early in my career my need for recognition and attempts to discover new ways to combine technology and art put me on just such a heroic quest, fighting for originality in the studio every day.

In his 1949 publication *The Hero with a Thousand Faces*, Campbell recognizes the "heroic quest" or "monomyth" as a basic pattern in storytelling throughout history and amongst most of the world's cultures. Campbell writes, "A hero ventures forth from the world of common day into a region of supernatural wonder: fabulous forces are there encountered and a decisive victory is won: the hero comes back from this mysterious adventure with the power to bestow boons on his fellow man." Among the seventeen well-defined stages of Campbell's monomyth, one emerges as very relevant to creative practice. It describes the hero's departure from his home and family into a realm of the supernatural, entering a space of almost complete unknown—the "crossing the threshold" stage.[1] What better way to describe our decision to begin a drawing and make those first marks on a blank page than to compare it to the beginning of a journey into the unknown? A similar comparison could be made to sitting down and meditating: Who knows what will happen?

Considering the "crossing the threshold" stage: the hero decides to do something and takes the steps to carry it out. In adventure stories, malicious entities often stand guard at this boundary that marks the start of the journey, and the hero

1 Joseph Campbell, *The Hero With a Thousand Faces*, (Princeton: Princeton University Press, 1949).

must overcome them to begin. Now consider how closely this stage corresponds to getting ourselves into the studio every day, facing a blank canvas, and finding a way to begin making marks. It requires similar effort to stop and pause our daily activities, carve out some time, and sit down to a regular meditation practice.

If we anthropomorphize the forces that resist creative work and see them as demons, what monsters do we imagine, what blocks the artist's way? With social media streaming live to our screens and so much incredible and interesting information to watch and read online, I have to say that the largest monster I must slay most days is the dragon of distraction. These threshold demons are also manifestations of our inner critics, dispatching their minions of doubt and fear.

As beginners, we hesitate to take up the pencil because we doubt our ability to render realistically. As we gain experience by drawing more difficult and time-consuming subjects, we doubt our commitment. Control of the pencil only sensitizes our eyes to details we haven't mastered and how much more there is to accomplish. More demons emerge. What am I doing these drawings for? Can I justify the time I'm spending on art?

Fear of failure is always ready to strike, especially when we expose ourselves by taking big risks in composition or color. Fear raises its head even in the last few strokes of a drawing when we believe one wrong move could ruin the work. Have I gone too far? But wait, we now encounter the ephemeral but paralyzing fog called "social convention" floating above the studio, casting a cloud on our process when we ask, "What will others think of this? What kind of person spends all day drawing? What value does art have anyway?" If the hero wants to continue to create, these demons must be defeated.

Once over the threshold, the journey continues. A hero faces danger in many forms, moving steadily toward a climax when, characterized by both personal and material transformation, something dies while another thing comes into being. A lone individual at the turning point of the story fights and slays a dragon or risks their life to steal fire from the gods, transforming human life. In the creative process, the multidimensional vision in the artist's mind dies when it is reduced into physical media; what is imagined does not become the object, but the inspiration is

reborn in a material with its own properties. The artist trades an inner feeling for a tangible symbol that can be seen and shared. The artist-hero snatches beauty from the gods and brings it to Earth. The journey ends when the hero returns to the ordinary world with something to share, a boon to enrich others or relieve suffering. From the creative point of view, the prize is the artwork itself and the ability to show it. The inner prize for the artist is more experience and the ongoing dialogue with the object made, being able to read it in wider perspective over the years.

Artistic failure in the hero's journey would be disillusion, losing track of the vision that began the journey. Too often financial worries take precedence and the inner journey is neglected. The fight for money is tangible, the rewards can be added up. The spiritual benefits are qualitative and require more sensitivity to value.

What is it like to make artwork along the heroic path? Campbell's map focuses more on resistance in the path and less on the joys and integration of the creative process. The hero undergoes inner transformation but in ways that are often unexplained, yet his map is useful as a call to arms. It alerts us to how much effort it will take to get any endeavor started and may inspire us to the level of discipline that it takes to sit on a meditation cushion every day or to finish a piece of art.

Through the mid-1990s, while I was struggling to find my way in the art world, searching for undeniable iconic images, Joseph Campbell's description of the hero's journey gave me the courage I needed to take risks; the hero's journey inspired my self-discipline to persevere. Trying to make art for a living felt like a heroic act, each artwork a treasure brought back from the unknown. This story helped me manifest work and bring it to market, but the guidance began to break down when inner growth was called for. By 2002, when I started to question the source of my ideas, I knew I needed to search for another story, one that could also offer guidance in handling my feelings, as I was still being blindsided by strong reactions to criticism and learning to let go of work. What I discovered next offered this and much more.

Embedded Sources

In this exercise we begin to make our map, starting now and working back in time and space toward our creative sources. The objective is to choose anything in the place where you are reading this, or the place itself, and trace its path in your life. For example, I sit in my studio and make a mark on a piece of paper because I love to draw. I discovered my love for drawing at an art school in New York City. I was attracted to move to the city after my parents took me to Greenwich Village in 1969, where I saw real hippies and realized how different life was outside Louisiana. I was born and raised in Louisiana because my parents lived there; they were in the United States after their ancestors left Europe. And further back it goes, the story choices becoming broad and diffuse. From this perspective, do you see how each mark we make carries our stories forward? How many different paths does each life weave together?

In this exercise, choose one of your drawings and sit with it, seeing what comes up when you consider the history of its making. I can show you how to get started, but you have to fill in your own particular narrative and see where it takes you. For example, "This drawing on my table exists because I followed the exercises in this book, and I bought this book because I'm interested in ways to incorporate mindfulness into drawing, and that interest in meditation comes from . . . " I leave it to you to fill in your own path. Try this exercise at least three times with the same object and follow different routes. Compare the variations in how you tell the histories. Through this exercise, we can begin to see how complicated it is to define just where creative ideas come from.

Amplifying Presence
04.24.2014

Drawing Your Own Path

Discovering the ox

My own hero's journey ended when those growing doubts, fears, and self-criticisms finally got the better of me and I turned my attention inward looking for peace. Instead of pursuing gallery sales and reviews, by 2005 my commercial success felt one-sided; I wanted to know more, to discover the source of my creativity, to see where the art was coming from, and to explore why it felt so good to make drawings. Luckily, right when I needed it, I found the perfect map, sometimes referred to as the "Ten Bulls" or "The Ten Ox-Herding Pictures," a Buddhist teaching describing the path to enlightenment in ten stages, presented as a mixture of poetry, drawings, and commentary. To say that this teaching was important to me would be an understatement. It felt immediately personal because words and images were given equal weight—each conveying what the other couldn't— creating an excellent example of how creativity and meditation interlock. I was sure this teaching would point me back to my creative source and it did, but that was only the beginning.

The ideas and symbolic imagery in the ox-herding pictures have a long history. For centuries in Buddhist texts, untamed animals, such as a young bull, a monkey, and even an elephant, have been useful metaphors for a human's uncontrolled mind. The wild bull, perhaps because of its familiarity to the farming culture in twelfth-century China, was an especially resonant image and "at least four versions of the bull-taming or ox-herding pictures of the Chan (or Zen) tradition have been identified."[2] Within that history, Chan Master Kuo-an Shih-yuan of the Sung dynasty composed his own version of the ten poems and images. Those poems were translated and interpreted in 1999 by John Daido Loori and published in his book *Riding the Ox Home: Stages on the Path of Enlightenment* (Shambhala Publications, 2002).

..............

2 Piya Tan, *The Taming of the Bull. Mind-training and the formation of Buddhist traditions*, 2004, [website content, dharmafarer.org], retrieved from: http://dharmafarer.org/wordpress/wp-content/uploads/2009/12/8.2-Taming-of-the-Bull-piya.pdf

I relied on John Daido Loori's translations and commentary to guide me as I composed my own versions. Reinterpretation over the years of both the images and poems is not uncommon, and gaining that level of familiarity with the stages seems to be a good study practice. John Cage, the renowned composer and visual artist whose work often reveals Buddhist influences, created a group of his own abstract and minimal ox-herding pictures, published along with his poetry, demonstrating to me how balancing the accidental with the intentional, so common in meditation practice, can be beautifully expressed in visual art and poetry.

I recognized how this ancient Buddhist teaching, told through drawings and poems, revealed the spirit in art, not art as decorative objects, like paintings and sculptures, but as a dynamic, ever changing, and approachable living presence. Working with the ox-herding pictures changed my views about the goals of studio work and how deeply practice and life could entwine. The ox-herding pictures present an orthogonal perspective on creativity, beyond the flat surface of the paper, revealing the many layers of human responses through which images transmit. Studying the ox-herding pictures proved to me that the source of creativity is real and accessible through practice.

It is important to point out that the pictures themselves are more than just illustrations of the accompanying poems and commentaries. The images are complete lessons in their own right, conveying a different kind of information than the poems. Visual transmission through images speaks directly to intuition and feelings, circumventing the verbal mind. Drawings offer spaces for imagination to wander, evoking meanings too complex or subtle to know intellectually. This state of mind, in which one can receive information through images, points to one of the closest parallels between the contemplative and creative paths. Aesthetic appreciation and receptivity to spiritual teachings are both practiced with an open-ended state of mind, a state of comfortable not-knowing. We draw and meditate in heightened awareness of what is happening in the moment, opening the space for new ideas, and allowing change to happen.

I love this set of drawings because I find great pleasure in receiving a beautiful teaching via a beautiful path. It was through my continued contemplative practice

and study of the drawings that a resonant layer of meaning began to occur to me. I saw the ox-herding pictures and poems functioning as a descriptive map of the creative process, working simultaneously alongside the spiritual teaching. It seemed to me that each stage described a step an artist goes through when carrying a work from inspiration to completion. This parallel has been confirmed for me in various workshops as artists share the details of their own creative processes.

For example, when I notice myself steadily working to render a leaf, I say I am at the stage of taming the bull—the stage of meditation characterized by increased patience and discipline. I find it practical to use the well-defined stages to consider where I might be stuck on an artwork and seek advice in the teaching for what is required to move forward. I like that the ox-herding pictures do not leave out the hardship and struggle encountered in completing a creative project. Art requires effort, discipline, and patience, but the ox-herding pictures also show that the struggle comes to an end. The whole cycle of ten stages can be applied on multiple time scales, from a single meditation to an entire life, from a single drawn mark to a creative career.

In the next section, I offer you my interpretation of the ox-herding pictures seen through the lens of the creative process. I offer this map of the artistic path for practical use in the studio because I have found the feeling of each stage closely resonates with my own experience going through the cycle of wanting to make something, making the work, evaluating what was made, and moving on. The fact that it is based on, and seems to follow closely, a well-defined spiritual path has given me confidence in following it and I have not been disappointed. The following improvisational drawings and poems were made while meditating on each stage.

The Creative Path

1 Curiosity

Creatively seeking,
Mind awakening,
Curiosity energizes
The desire to make.

In the first stage of the creative journey my attention wanders, maybe for minutes, maybe for years. I am searching for something. I can't stop myself from exploring—I am curious. Maybe I see a spectacular sunset, a beautiful person, or even a train wreck. It could be as simple as a feeling that the furniture in a room should be rearranged, a feeling with accompanying thoughts such as, "I can't let this experience disappear, I must remember it," or "This experience is not right, it must be changed!" I want to take action when my curiosity gets engaged.

2 Taking Initiative

Creative energy will not dissipate,
Turning over and over in my mind,
Suddenly I see the media and methods,
I resolve to undertake this work.

In the second stage, the process of making an artwork begins. Sometimes I grab pencil and paper in an inspired moment, but much more often I rely on regular practice and self-discipline. I never find it easy to reduce the expansive, flowing sensation in my mind into concrete, physical materials—I always feel like something gets left

out—but I persist. At this point in the process there are few rewards and lots of doubt, but for right now, doing something is more important than what gets done. In my twenties I felt desperate if I did not draw. Even today my feelings about practice are so strong that I "can't not" make art. What could be driving that?

3 First Glimpse

Now the page is no longer blank,
Tentative marks, sketchy lines,
Overcoming my hesitation and shyness,
The goal is far but the journey is underway.

In the Buddhist tradition, the third stage of the ox-herding pictures, "seeing the ox," marks the first glimpse of the true self. It can be a practitioner's first time experiencing the value of the Buddha's teachings, trying out meditation, or turning thoughts inward; doing just enough practice to return a reward.

On the creative path, this stage happens during mark making and warm-up exercises, when the artist settles their mind into drawing and starts to see the first gestures, now doing it "for real." I get a physical sensation in my abdomen, joyous butterflies, a lift that comes when I have broken the symmetry of the blank page and started a drawing, the graphite line, charcoal smear, or flash of colored paint now in my sight for the first time, mine to work with. I know what the material feels like. I'm underway! The drawing is an object I am working with but also a reflection of me, not separate from me, the universe glimpsing itself from a new angle. I feel my attention being pulled into the page, my focus narrowing, and I start to "see" what this new world holds. Even small gestures inform the growing idea. Lines made at the beginning direct the evolution of a drawing. When working with the infinite, even a single mark is enough.

4 Catching a Likeness

Seeing the thing that looks like the thing
that looks like nothing I've ever seen.
To get something working in the drawing
I move outside the ordinary.

Sketchy marks give way to more evocative con-
tours. In a single line I manage to catch a likeness.
I've seen enough to commit to the drawing but
I haven't gotten to any depth. At this level of
experience, I can ruin a promising sketch with
too many lines as easily as I can deny myself an
excellent drawing by stopping too soon, afraid of
overworking it. Here, through practice, I build
good judgment by making lots of quick studies. I see tantalizing potential but only
manage a few drawings that deliver. This stage is asking me to step up and be more
clever, to experiment and invent techniques that show me my own way of doing
things.

The parallel stage on the contemplative path is marked by the practitioner
reaching a moment of clarity that quickly vanishes because concentration is still
weak. The danger here is mistaking a small success for mastery, a sketch for a fin-
ished drawing, an insight for enlightenment. Catching a likeness takes effort but
the result is powerful. I must have patience.

5 Taming the Image

Just drawing, just drawing, just
* drawing,*
My attention is on technique
Building intuition, exploring
* possibilities,*
And improvising in the moment.

Fundamentals practiced, focus growing, and likenesses common, I build my tools for aesthetic discovery and begin to add layers of meaning to the work. Daily discipline is still needed to get to the studio, select paper, pick up pencils, and to initiate marks until the practice returns more than it takes. But I am careful not to push too hard; art is best tamed by enclosure, not force, slowly bringing the practice to materials, allowing for play and mistakes. If drawing is fun then why complicate things? The only thing I need to do is mindfully observe. On my contemplative path, I apply discipline to get myself to sit every day, making sure my practice is regular, but not so forcefully that sitting becomes a chore.

This is not the spot to fall back on comfortable patterns to get a satisfying result; I'm only just starting to like what I'm seeing on the page but I must remind myself to continue to experiment with materials and techniques. What I'm after is an attitude open to possibilities, one that allows me to adapt my marks to what each developing drawing suggests. I feel confident in the work at this stage but I know I'm a beginner. By allowing "what is" to arise in the drawing, a more mature style develops. Facing the blank page every day was humbling but exciting at first and now feels absolutely familiar.

Beyond limits
Pencil and line
Creator and created
Dancing a dance.

Art is happening. Lines and colors appearing on the page are now guided by intuition and fueled by the excitement of making. The feedback is self-sustaining. I am happily out of the way, allowing the marks to arise, and mindfully observing the process.

In this stage the creative and contemplative paths are almost identical. The classic ox-herding drawing of stage six depicts a musician, an artist, riding a tamed bull and joyfully playing a flute. Creative flow is our example of having achieved a natural and accomplished meditative state, a deeply formed connection to the source. When I am in the flow of making a drawing, improvising intuitively, there is a sense of being controlled by a supernatural force, that some creative energy is doing the drawing.

Many times I have made a "really good" drawing and immediately attempted to make more copies in that style only to find the new work appear derivative, lacking the spontaneity that made the original so attractive. I've duplicated the visual forms but not the flow state. It is only by returning to curiosity, following the stages, and allowing forms to arise that I can give life to new work.

7 Returning Home—
Noticing the Sense of Completion

Beauty resonates!
Not one line, one mark, one color,
one word, one note, one thought,
not one thing is out of place.

How do I decide when a drawing is finished? To
learn to see when things end, let's make use of the
powerful noting practice that meditation teacher
and author Shinzen Young calls "noting gone." He
instructs, "Every time you are aware that something
has vanished, note 'gone.'"[3] This noting technique has been very useful to me when
I ask myself if a drawing I am working on is finished. I start by looking at my draw-
ing. Often it feels unbalanced or a line bothers me or a color is too bold. I make
a change, step away, and look again. Do I think some part still needs fixing up?
When this need to fix the image is no longer present, I note that the need is gone.

This feeling I'm describing, of wanting to change things in a drawing, does not
go away all at once. For example, I may love a new drawing when looking at it from
one point of view, only to see something I want to change after I step to the side, or
go out of the room and come back, or when the light shifts.

Practicing this "noting gone" exercise with my drawings made me more sensi-
tive to noting the presence or absence of other feelings I had when looking at my
work, such as pride in my technique or fear of messing up. As the noting in the stu-
dio became more automatic, I noticed I was observing changes in my thoughts and
feelings in life outside of the studio.

.
3 Shinzen Young, *Return to the Source*, 2006, [website content] retrieved from: http://www.
shinzen.org/Retreat%20Reading/Return%20to%20the%20Source.pdf

8 Drawing and Self Forgotten

The image I dreamed of is here,
before me and not here at all,
the image and the imaginer
entangled.

While I'm busily noting changes, the self and the drawing are forgotten. My foreground story of "an artist making a drawing" shifts to the background. Both the vision that brought the drawing into being and the excited artist who couldn't wait to make the marks become part of a wider view of an ongoing process. No more searching for an image and no need to make.

Knowing the drawing is done I can now ask, "What is this? What does it mean? Have I grown from the process? Who made this?" The deep feelings that formed the image in my mind and the initiative in my body can now be contemplated externally because I brought them into the world using graphite and paper. Were they ever separate? The traditional ox-herding image for this stage is the enzo, a symbol for wholeness. My world now contains an object that feels like part of me.

9 Sitting at the Source

Seeing the path in perspective,
Hearing echoes from the journey,
Sitting in the studio
Familiar surroundings are refreshed.

In one memorable scene of Wim Wenders's film *Wings of Desire*, the actor Peter Falk, cast as himself, makes a speech to address the concerns of an angelic entity he senses nearby. Falk extols the virtues of being present in the world and the pleasures he feels by being physically equipped to sense that world. Standing in front of a food truck in the early Berlin dawn, Falk speaks to an angel that only the film audience can see. "I wish I could see your face, just look into your eyes and tell you how good it is to be here. Just to touch somethin'. Yeah, it's cold. I feel good . . . Look . . . Here . . . To smoke, have coffee, and if you do it together . . . it's fantastic. Or to draw: you know, you take a pencil and you make a dark line, then you make a light line and together it's a good line, or when your hands are cold, you rub 'em together . . . that's good, you see that feels good. There are so many good things!"

When I began my journey to the source of creativity, how could I have known I was already there? I had no idea that my travels would eventually come full circle, back to the awareness that made me curious about it in the beginning. I finally realized, "What else could be the source but this?" I saw creativity in everything. Art is the expression of this, of what it is like to be present, and to truly sense it. This saying of Chan Master Quingyuan in the Wudeng Huiyuan (Compendium of the Five Lamps, 1252) can be rephrased to summarize how we approach the creative path, become intensely absorbed in our work, and finally step back to spend time reflecting on the result. Before I came to drawing, pencils were only pencils, paper only paper. After I began to draw, pencils were no longer pencils, paper no longer paper. But when my drawing was complete, pencils were just pencils again, and paper just paper.

10 Return to the Market

Who will see this beautiful drawing,
who will engage and be willing to share:
a circular path of endless production
and liberation through unselfish care?

After all the making and introspection, it's time to take my drawings and show them to the world. The ox-herding picture presented at stage ten shows an experienced (and we presume, realized) meditation practitioner entering a village market and sharing wisdom. Artists especially will relate to the market as the last transition in the journey. The picture is done—now it is time to share the message and possibly sell the object.

Forget about awakening and enlightenment—when I started on the creative path my ego was in control. I was focused on the rewards at the end. After traipsing around the creative cycle thousands of times I now look at my drawings through

layers of experience. When I teach, I emphasize practice and technique, but only so the student gains enough experience to be able to point out to them the layered view they are naturally building. The approval and acceptance from the market only occupies one note. Recognizing a larger resonance is the best reward: to live a grateful life in that creative spirit.

Mindful of the Path

I often encounter resistance when I'm drawing—maybe I'm hesitant about tackling a complex rendering or I have lost confidence in the purpose of daily drawing or I'm just disappointed with the way one small line looks. If I know that I am blocked, I can use the ox-herding pictures like a map to return me to flow. The key is being familiar with the stages and transitions—not just in theory but knowing how each stage feels and being skillful in deciding what changes signal when I've moved from one stage to the next.

To build that experience, I ask you to do three things at once: make a drawing, note each step of your process as you do it, and decide which stage of the ox-herding path that step best fits into. For example, I sit and consider this exercise and I note that I am interested in trying it—that's curiosity. I pick up a pencil, noting that I am no longer just curious but I'm willing to try—I am taking initiative. Later, after the initial thrill of the first marks has worn off, I look up and note that I feel like chucking what I have done—I need effort here as I try to tame the image.

With a little practice, I find I can allow the transitions to occur naturally as I work. I focus on the movement of my hand and what my eye is telling me. The familiar process of daily sketching dictates the pace. See if you can recognize and resonate with each phase as it happens. See if the map rings true for your own path. Maybe there are some places you visit that aren't yet mapped?

A bonus practice: if you find you respond strongly to the path described in the ox-herding pictures, I encourage you to make an image, an illustration or improvisation, while meditating on each stage, and create your own personal map of the cycle.

Possibility Library
03.31.2013

7
META-DRAWING

The valuable lesson I learned from the Ox-Herding Pictures—that creative and spiritual growth could happen simultaneously—energized my daily practice and reinforced my confidence in the value of intuitive drawing. Although I didn't recognize right away what was happening, the more I let go and allowed drawings to emerge, the more time I spent in a mindfully aware state—and as a result, the more the benefits of meditation began to accrue. The intuitive drawing practice finally came full circle when I embraced the tenth stage presented in the Ox-Herding Pictures—the return to the market—that points out the necessity of integrating creative work into daily life.

I began my process of integration very simply, by finding places to display drawings in my home where I was sure to see them, sharing my art with myself, and accepting that the pieces were worth further consideration. Then I invited others to see the work and had longer conversations with those who expressed interest. Finally, I put the drawings into public exhibitions and worked with the feedback I got from a much larger audience. These activities outside the studio might seem like distractions from daily, focused, meditative drawing, but without regularly reflecting on creative work and taking the time to meet and talk with other artists, studio practice gets insular. So although some of the practices in this chapter might feel awkward and un-meditative, I strongly suggest you stick with them. Reflecting on your own work, discussing your work with others, and making your work visible to a larger audience are not options: they are *essential* aspects of growing as an artist and, if done mindfully, as a person.

Sharing with Yourself

In Chapter Five, you wrote four descriptions for one drawing: your observations of the materials, stories about the content, explanations of the symbols, and universal themes. In Chapter Six, we widened our focus from telling stories about a single drawing to being mindful of the way we made the drawing, trying to see creative transitions in the making as they occurred. In this practice, we take an even wider view, one that considers the variations among multiple drawings over a longer period of time.

What can we learn from studying how our drawings evolve? What features characterize long-term practice? We will use three steps to analyze a group of drawings: first a "short read," where we find similarities; then a "long read," where we look at how those similarities transition; and finally an "inside read," where we locate the transitions on a larger map.

First, let's do a body-scan style meditation on our body of artwork, looking at what we have drawn over a period of days, weeks, months, or years. The goal is to reflect mindfully on a large group of work, paying special attention to how we feel about what we see. My daily drawings are made on individual cards, which are easy to lay out on a table and rearrange. Choose a time period—a week, a month, or longer—and lay out all your drawings. (You may wish to use the work you have done in the previous chapters.) It is important to display entire sequences, to lay out everything you drew during that time period and not just to choose the "good" ones. Notice if you feel a need to arrange the drawings in any special way or edit some out. Include false starts, half-finished works, and larger and smaller pieces, and select a long enough time period of the pieces so that dissimilar works can be included—which is one way we can discern the edges of the transitions.

Short read

While the drawings are lying on the table or hanging on the wall, live with them

for an hour or even a day as you do other things—move around them, enter and leave the room, see them from different angles, and look at them in a mirror in different light and as your moods change. First notice your "short read," or immediate response. Do you feel a positive response when you glance at the layout or do you cringe? How long does the group hold your interest? Maybe some sketches that you thought were finished now look like they need more work. Note how the whole group makes you feel and a few reasons you are attracted to the ones you like.

First we search for similarities in the drawings. How are they alike? Identify any persistent symbols, colors, or compositions. What words generalize this group of work? Were they all made in the same medium? Are there a majority of centered compositions surrounded by white? Are they predominantly heavy, dark colors or bright pastels? How are the edges handled? Do you make mostly portraits of friends, sketches of animals, or abstract compositions? Can you come up with more than one label for the group? I once had a run of drawings that lasted several months where every few days the figure of an elephant appeared. A series of works I produced during my Conceptual Art fascination in the late 1990s can only be described as quick improvisations with vertical lines.

Long read

After we've interacted with the images for a little while, it's time for the "long read." Here we switch modes and find all the differences between the drawings: if you first identified persistent features, now pay particular attention to how and when those regular choices, symbols, or styles change. In the mid-2000s I was caught in a repetitive pattern of drawing unstable stacks of cubes. I would sit down with the intention to allow anything to arise, hoping for novelty, but over and over again only the stacks appeared. At first the persistence of the stack was satisfying, amusing, easy, and fun. I had a thing, and there was plenty to explore and discover while playing with variations of cube geometry, light angles, shadows, roughness, and degree of tilt. Just how tippy could I make each stack, or how stable? I invented stories about the stacks' instability and compared my

new ideas about compositional balance to Paul Klee's *Tightrope Walker*, satisfied that my historical justifications lent weight to the pieces. After months of seeing these cubes and not much else, I began to get annoyed. I was not obsessed with cubes but they persisted. If I allowed myself to truly follow my hand, tippy cube stacks were all that came out. Once I even asked out loud in the studio, "Okay, why these stacks?" but got no answer.

On September 15, 2008, I was in Spain, three days before I opened a solo show of new software artworks called *Color and Time* at the Javier López Gallery in Madrid. That was the day Lehman Brothers, a financial services firm, went bankrupt, and the next day insurance giant AIG faced a similar crisis—thus unfolding a global financial collapse. Credit markets froze, and banking institutions had to be helped by governments to overcome their exposure and losses. The art market, and my business, suffered significantly as a result of this drought of capital. Within a week of the opening, sales that had been closed during the show were canceled, pending sales fell through, payments were stopped on pieces already being paid for, and prospects for new sales were slim. Amidst the anxiety and fear of those uncertain days the stacks in the drawings toppled, and soon after were replaced by a new persistent symbol, the cycle.

During the recession that followed, I clung to my daily drawing practice. Eventually I realized how little anyone outside my immediate circle of family and friends knew about these small drawings that I had been making daily since 1999. So out of the ashes, so to speak, I began to upload a drawing a day and to write about them on my website, www.iclock.com. I have now created more than 2,500 new drawings since that time of crisis in 2008, all freely viewable online. I am sharing this story of how and why the stacks changed into the cycles not only to describe a dramatic transition in long-term, persistent imagery but also to illustrate the larger theme of this chapter: the importance of connection to the outside world. I discovered for myself, in an emotionally intense moment in my life, the therapeutic value of sharing creative work.

The transition I saw in the drawings in 2008, from the stacks to the cycles, was unmistakable. But generally in my work, a set of smaller, un-storied, and

less traumatic transitions happen quite frequently from drawing to drawing. For example, I will sometimes switch, for no apparent reason, from a horizontal to vertical format, from pencil to gouache, or from repeating patterns to a single composition. As you look over your group of drawings, see how many changes you can note in both material and concept. Do any stories come to mind to "explain" the transitions?

Inside read

Finally, as you should now be much more familiar with the body of work you laid out, we can make the "inside read" and try to assess where this body of work lies along the path mapped by the Ox-Herding Pictures.

Does this work feel fresh, experimental, and playful? Does the imagery vary quite a bit with few persistent symbols? Are the stories that come up simple? Has a recognizable personal style developed?

The first steps along the path are about fascination with novelty, moving through discovery, and pursuing curiosity. If you are new to drawing, this is the phase of becoming comfortable, actually sitting down with pencil and paper, and justifying the time you are taking out of the day to draw. Experienced artists will recognize that we cross this territory at the beginning of each image, and more so when starting a new body of work. When any artist goes outside their comfort zone by trying an unfamiliar medium, technique, or subject matter, they introduce the possibility of redefining themselves as artists and asking others to adapt to that change. Phase one is characterized by experimental styles and bold variations.

Perhaps you have a tighter grip on what you are doing. Does the set of images you chose have dominant, consistent features? Can you name the symbols, summarize the style, or tell a detailed story about the images? If so, you are moving through the middle phase of the creative cycle, developing technique, refining your marks, and flowing with familiar imagery. This phase is one of deep absorption in the work, where the most intense physical manipulation and mastery of materials takes place. Without adequately setting our view before

entering this phase or taking time to listen to and reflect on what others say about the work, an artist can get stuck in a production loop. Phase two is about a maturing practice and a deepening understanding.

A third possibility for an inside read is noticing a feeling of accomplishment. Are you comfortable and maybe even proud of that amazing portfolio of drawings? Are the techniques beautiful, the subject matter well understood, and the levels of detail refined? Perhaps a persistent motif has grown into more prominent works, even paintings or sculptures. These are undoubtedly finished pieces. Here we enter the completion phase, described in the seventh, eighth, and ninth Ox-Herding Pictures, where the focus is on reflection and letting go.

In which of the three phases described above would you locate the body of work you have assembled? Once we have completed this exercise of summarizing and evaluating a large group of our drawings, the next step is to return to the studio to continue our work, pushing the technical and conceptual boundaries we just identified. But the artistic path is not a solitary path, despite the stereotype of the struggling artist alone in the studio. In order to grow, there comes a time when we need some solid, trusted advice, and we need to expose our work to others, even those who might not like it or support us. In contemplative practice I have found the same threshold. I can meditate alone for a certain amount of time, but real growth eventually requires seeking out an experienced teacher and a *sangha*, a community of fellow practitioners. Real growth requires hearing things that challenge our view, listening to guidance that comes from outside our head. To enter and complete the tenth stage of the Ox-Herding Pictures, we're going to need help from a friend.

Believing in Earth
12.11.2012

The benefit of trusted friends

In August 1987, I completed my master's degree in Earth and Planetary Science; my graduate work focused on writing software to process digital telescope data. Later that month I moved to New York City to begin my first semester at the fledgling Master of Fine Arts program in computer art at the School of Visual Arts. While my experience in programming was an advantage in this new medium, my art skills were woefully underdeveloped, relying mostly on technical process. I spent my first months in the city pulling all-nighters at the school, as it was the only place I could access computers with color graphics.

When I arrived at the computer lab one morning, I was surprised to find the doors locked; it was Thanksgiving break and I couldn't get to my precious machines! It was a defining moment: little did I know that in being turned away from technology, I was being turned toward art. As I stood in front of the locked doors, around the corner and as if by fate, came Uri Dotan, a fellow first-year student in the MFA program. Uri was as fluent in art as I was strong in programming; over time and by example, he transmitted to me his style of living creatively and I translated for him the secrets of Unix and C programming.

That morning we wandered down to Macdougal Street in Greenwich Village and hung out at Caffè Reggio, drinking cappuccino, eating tiramisu, and talking about art and computers and the integration of the two. It felt like a scene from a movie. We forged a friendship that day that remains strong now, thirty years later, and our discussions about art have not lost any of their intensity or relevance to our practice.

There are, of course, many stories of deep friendships in the arts. The artist friendship is one of long-term trust and depth, a relationship with someone who must be sensitive to the risks your work takes, readily celebrates your victories, and suggests alternatives to your more challenging experiments. In short, it's good to have a buddy who has similar goals and work experience, and I certainly lucked into one that day in New York.

The ideal artist friend should be someone sensitive to the vulnerabilities you

feel in presenting new ideas or new sketches, especially when showing experimental art that you see as a personal breakthrough but fear no one else will understand. The ideal artist friend will face the same issues in their own work. Discussions of creative work can reach the level of intimacy found between meditation teacher and student, as both work with experiences of deep contemplation. Buddhism has much to say about growing through personal interactions; some of these ideas can be especially helpful in thinking about collaborative creative friendships. The Pali term *kalyana-mittata* means "admirable friendship," a relationship in which peers act as teachers, exchanging wisdom and finding justification in each other's interests to continue to practice. The Upaddha Sutta recounts a dialogue in which the Buddha extols the virtues of such mutually supportive relationships, pointing out that these kinds of dialogue naturally encourage an individual to develop the factors that lead them along the Noble Eightfold Path. And of course the sangha, or community, is so important it is considered one of the Three Jewels of Buddhism, alongside the Buddha and the Dharma. We also find similar advice in the second chapter of the Bhagavad Gita, when Krishna names the company one keeps as the chief influence on the habits and goals one develops.

What I found over time was that opening my art to others was much more challenging than making it. Uri and I shared studio space on 21st Street during 1993–94; there was plenty of cross talk, and no small amount of competitiveness, while we developed our work. Some afternoons, especially when one of us was experimenting with new territory, we'd sit down and have formal critique sessions, meetings where we worked together to identify what a new drawing was trying to be, where it was going, and how to make it better. In my enthusiasm to point out to him some ink line in a pen-plotter drawing that deserved special attention or the way a scene changed in a software animation, I would often carry on my explanations for too long, offering too much theory, until Uri would just scrunch up the side of his face, wave his hand side to side in the air as if to shoo me away, and say, "John, just be quiet and give me time to fall in love with the piece." I would sit quietly while he concentrated on the work, and pretty soon, often in about the amount of time it takes to finish a cigarette, he'd grunt, squint his eyes, and point

to a place in the drawing I somehow hadn't considered. Or he'd pull back to see a connection I'd never made, telling me how the piece sat with him, and he'd find the things that worked and those that looked too amateurish. Now that I live outside of New York City, studio visits happen less frequently but I have found many communities online where I can display my work, discuss art, and practice drawing together.

If you already have trusted artist friends, that's terrific, but what can be done if no fellow artists live near you or if they're not available when you need to show a new piece? Fear not, there are ways to have useful dialogue with any interested person. You can include willing family members and close friends in your creative development. Are they willing to help? In *The Zen of Creativity*, John Daido Loori offers a mindful approach to discussing art with nonartists, and I have found that the method he describes works well for any who are interested, regardless of their art experience. He calls the method "creative feedback" rather than critique, and it requires no knowledge of art history or formal artistic analysis. All it asks of the observers is to look inside themselves in the presence of the work and talk about what feelings come up; while most critiques center on what the viewer sees in the picture, the creative feedback method turns the view around, looking inside the viewer to measure the effects of the work.

Creative feedback takes some time to master for both the artist and the viewer, as it is more dependent on the relationship between them than on what each person says. When looking at art, our tendency is to react to what we see: "I love the blue color," "That looks like a barn," "It's scary," or "The patterns are neat." Instead, the creative feedback method asks us to try to recognize input from our senses, emotions, and thoughts, offering the artist, for example, the sense of tightness in our throat or the memory of the smell of the ocean elicited by the piece. (This sounds a lot like the noting practice I described earlier, doesn't it?) Creative feedback requires both parties to employ a certain degree of mindfulness: the viewer must take a bit of time to be quiet and tune into their own awareness and responses. In turn, the artist must be careful not to become identified with what is being said and not to take every comment as a judgment of their talent. They must

try to listen to the viewer's feedback with fresh ears and an open mind, making an effort not to hear only what they want to hear.

Showing your work to another person usually begins with a highly energetic moment when the work is revealed. How someone reacts to your work is often rewarding, but just as frequently it can lead to frustration and tension. Viewers are sometimes self-conscious and reluctant to say things, falling back on clichéd phrases, and artists are often vulnerable and sensitive to feedback, especially about new work. Even with more than thirty years of practice, when I share my work with others, I still feel as vulnerable to negative comments—or worse, to no reaction at all—as I did when I first started. To ease the tension and let your viewer know that they do not need any special knowledge or terminology to be helpful to you, be sure to explain clearly at the outset that they should discuss only what they feel, not what they see.

In the late 1990s, another artist and I shared a workspace on 27th Street in Manhattan consisting of two large unused offices that we rented from a wine importer. My space was affordable by New York standards, but the catch (and there's always a catch) was that my studio mate had to pass through my space to get to hers. She did not come and go very often and we were very friendly, so I didn't mind when she walked through the space while I was working. It was a welcome break to see her. Surprisingly, I began to feel bothered about the arrangement in the times when I *wasn't* there. If I hung a new drawing on the wall before I left for the day, I believed I could tell the next day if she had looked at the work, because I knew it was possible that she had. Imagining that the piece had been viewed or judged by someone changed my relationship to it, and I still believe very strongly that work should remain private until the artist is ready to share. Before I make marks on paper, the work exists as a cloud of possibility in my mind, an impression, or a vision; when I finally show it to someone, I often feel like the image is somehow fixed and the possibilities disappear. However, honest dialogue with a trusted friend who can provide good creative feedback is different. This kind of dialogue allows the possibilities to remain open, and afterward you should feel energized to push your work further.

Sharing with a Trusted Friend

Let's see if we can use heightened awareness to examine this elusive transition, the shift in feelings that occurs when we show our drawings to someone else. What happens at the moment an artwork is revealed? For this practice we need an actual living person who is willing to participate. Invite a friend or family member to join you. You can do this with a casual acquaintance, but if the feedback proves to be mutually beneficial and your artwork grows, you will want to continue this practice. So try to choose someone willing to interact with you regularly. My friend Uri has witnessed many of my style transitions, and because of his intimate knowledge with my history, he often points out surprising and useful correspondences between old and new work. We meet, look at drawings, eat, and talk. I suggest meeting somewhere that serves food and drink or providing your own refreshments in the studio so that all the senses, including taste and smell, are involved. Spend the first few minutes visiting, catching up, and making sure the mood is relaxed. Sit comfortably. Enjoy each other's company.

Begin your first meeting by trying the following practice, which is not a critique of art at all but a focused study of internal states. Start by making sure you each have paper and a pencil; pause quietly for a moment to remind yourselves to be mindful, and then begin to draw, without looking at what the other person is drawing. Draw in whatever way is comfortable, for about five minutes. When the five minutes ends, it's time to take turns looking.

You go first. Display your drawing while noting what is going on inside you. What bodily sensations are prominent? Does your pulse increase or breathing speed up the moment your drawing is exposed? Which emotions—thrill, joy, nervous tension—are present? Do you feel foolish, embarrassed, competitive, or proud? Empty or full? Are you anxious because you want your partner to like what you've drawn, or hopeful that they will be impressed with your drawing

skills? After your friend has looked at the image, do you feel differently about it?

Now it is your friend's turn to show you their drawing. Notice how your feelings shift as you actually see the drawing. Do you judge instinctively? Do you immediately like or dislike what you see? To go even deeper, are you judging their drawing against your own, deciding which of you is the better artist? Does the image surprise or thrill you, make you laugh or gasp spontaneously, or burst into a smile? Pay attention to what thoughts and feelings arise, and try to let them roll through you. Notice your breath, just be present, and remember the emotions the other person may be feeling. Sit quietly and watch what comes up.

The descriptions I've gotten in workshops about this revealing moment vary from "fun" and "I don't care" to "It's not very good" and "I feel like I'm getting naked." What is really being revealed in this process? When we open ourselves to someone else, we remove our shells and our guard, leaving the opportunity for growth. Creative expansion requires letting go of any image we had of ourselves—"I'm *this* kind of artist"—discovering how others see our work, and learning from the differences between their point of view and our own.

When you have finished this simple exchanging exercise, how does the meeting proceed? What do you do the next time you meet? Now that the ice is broken, you are free to move the discussion to more finished artworks, working with one at a time, noting when vulnerability is present, and describing what feelings come up. You can also do the reading practices described in Chapter Five, listening to each other's descriptions and stories about the work. Have fun exploring this kind of sharing.

Public exhibitions

If showing a drawing to a trusted friend exposes our vulnerabilities, how much more exposed are we when we exhibit a large number of works at a commercial gallery or invite the world to see our art by posting it online? Opening our work beyond the scope of family and friends invites praise and recognition, but the process is double-edged. When work is included in an exhibition, our ideas become part of a larger dialogue, of public view, and of art history; but we also open ourselves to judgment. Maybe you'll understand why I wasn't on top of the world one spring afternoon in the year 2000, only a few short hours before my wife, my dealer, and I would dress up and attend the most important exhibition opening of my life. That year I had been lucky enough to have my work included in the Whitney Museum of American Art's prestigious Biennial exhibition. In my mind this was a career turning point, and surely a boost to my prices and sales at the gallery. Why then, that afternoon, in the calm before the storm, was I in the bathroom of my tiny Chelsea studio apartment hunched over the toilet, puking my guts out? It was not from too much alcohol, food poisoning, or the stomach flu—I was terrified.

What was I afraid of? I had worked very hard in the studio, schmoozed relentlessly, networked widely, and hoped against hope that someday I would be included. I had made it to a place that many artists dream about—that I had dreamed about—but the fact that I was a Biennial artist only brought up fear about how much there was to lose, and perhaps guilt because I had been selected for this show while deserving colleagues were left out. Even now, fifteen years later, I still get butterflies before my openings. A close friend who is a longtime surfer once said that if you don't feel respect and awe for the ocean every time you go out, you should stop surfing; this helped me see that my vulnerability to criticism and fear of unworthiness would always be part of my process around exhibitions. Gradually, over the years, I began to ask myself, given that exhibitions make me so stressed, what might meditation offer to help me calm down and enjoy the big picture? Perhaps what I've learned will be helpful for you in thinking about showing

your work to one trusted friend or to hundreds of people you don't know in an online forum.

First, I try to keep tabs on my ego. Praise feels good, and most people who attend a show will say, out of sincerity or politeness, how much they like the work. In those moments I remind myself to be grateful to have supportive friends who show up. I also remind myself that the work is not me—whether someone loves or hates it doesn't change who I am. Openings are usually so busy I hardly have time to think; it would be possible to get so ego-pumped that I would crash if I weren't able to step back and pay attention to my breath, note what is happening, and sit for a moment watching all of these reactions.

Amidst the mayhem of an opening, I try to take a few quiet breaks to look around, be present, and feel the support of the community, knowing that everyone's presence embraces and contextualizes the work. I receive the acknowledgment coming my way but try to make an equal effort to acknowledge my family, my dealer, and everyone involved.

Openings are extreme situations where my attention is highly focused on creative output and the anxiety and exhilaration of exposure. So they are great times to practice being mindful and aware of my emotions. I have also found, of course, that these same awareness practices can bring about similar insights in other emotionally charged situations like being stuck in traffic, waiting in line at the supermarket, working with my children, or just getting through a tough day.

Sharing with the World

In this practice, we use the public exhibition of creative work as an exercise in mindful awareness. If you feel ready, choose a way to exhibit your work to a broad audience. Show it to people you don't know and who don't know you, and use what you've learned about noting to remain aware of what comes up for you physically, emotionally, and mentally during the process.

Near where I live, there are many spaces where local artists exhibit, such as coffee shops, a special area in the public library, and small cooperative galleries. You can seek out these kinds of spaces, but you needn't be so formal. You can put work up on your refrigerator for family to see or out on the counter when visitors stop by, or you can anonymously pin it up on lampposts and sit nearby. Social networks, of course, make it easier than ever to show your creative work to large groups. I am a member of several online communities for daily drawing, art journaling, and contemplative drawing. Show as broadly as you feel comfortable and as opportunity allows. I can't stress enough the importance of this stage and what it will teach you. Exhibition is a reality check, but also a clear mirror. Be prepared to have people ignore your work as often as they admire or comment about it.

Even though I exhibit regularly, I find that I can never get enough practice dealing with the strong feelings that arise—how much I want viewers to like my work and how painful it is when they don't. As time has passed, I have gotten better at remembering that these feelings are temporary and that my work is not me. I show, teach, and speak publicly many times a year, and though the butterflies don't go away, they are now my valued teachers.

More One Than Two
05.28.2011

Finding the creativity in every moment

We've nearly reached the end of the path. What happens now? In this book I've tried to lay out how recognizing meditation and insight as an integral part of daily drawing can enrich your experience of your art and teach you valuable lessons about yourself. Writing about this process was both challenging and rewarding. By putting my thoughts and experiences into words, I saw more deeply into the source—more reflections unfolded for me, begging further investigation. I was challenged by the prospect of collecting my ideas and writing them down for you, and I see now that I probably learned as much as I hoped to teach. This process has felt like two cycles: first, the cycle of trying to understand contemplative drawing, and the second cycle of writing about it. And so I am asking myself the same question I pose to you: What happens next? Where do I go from here once this book is published? I don't have far to go to find out; however, just as we saw in the first chapter, the answer is in the question. When I wonder what happens next, I notice that I am being curious, and following curiosity returns me to the path.

If curiosity leads me to express myself through drawing, and the drawings in turn raise my curiosity, does that mean these cycles are endless? The answer is yes— but I have discovered a secret that I'd like to leave you with, a way to attain a new perspective on the cycles, a place from which you can watch the parade of changes. This view is a position outside continual change, as illustrated in this last story.

It was a special day on Avery Island, near the south coast of Louisiana. I had grown up in central Louisiana and even had family living in New Iberia, but I had never been further onto the island than the tourist's tour of the Tabasco Factory. Now I found myself at one of the McIlhenny's private homes attending my wife's family reunion, spending the weekend riding swamp boats, eating crab, and visiting the lake that formed when a salt dome was accidentally punctured by a drilling rig. The air was humid, of course, but it was a beautiful, sunny spring day in Louisiana, and I was on vacation with the family, sitting around, chatting, and deciding what to do with the afternoon.

Continually Creative
11.16.2012

Uncle Frank suggested we take a walk in the bamboo groves that are part of the 170-acre Jungle Gardens, a botanical garden and bird sanctuary on the island; he told us that the Jungle Gardens held one of the largest stands of bamboo in the country. It seemed very unusual to find a large bamboo forest in Louisiana, so naturally I wanted to see it. Uncle Frank also said that if we walked out into the center of the forest and were quiet, we'd hear a popping sound: the bamboo growing. Some species of bamboo can grow several feet in a day.

It was very peaceful walking in the bamboo. The clumps of growth and fallen canes made the forest very dense, but luckily there was a small trail. I was not much of a meditator in those days but I stood quietly and waited. Soon I heard my first pop, followed by many more random pops. It was exciting and remarkable, and I almost couldn't believe it—I was hearing the forest grow! Then a peaceful sensation came over me, a sense that I didn't have to do anything, that nature was taking care of itself. As I thought about this, it dawned on me how true it was. The forest grew itself in the same way that my body breathed. What are Earth's natural systems, living systems, always up to? Growing and reproducing! The living world is a creative place, because living things are always creating. Humans are not separate from this creation: our bodies grow new cells, create children, and continuously evolve, and our shifting brains make millions of decisions. We are creating our lives, while all around us the world is a creative place. As I stood in the bamboo that day, surrounded by the gentle popping sounds of creation, I realized that when I sit and draw, I am expressing that same creative energy. I open and let the drawings emerge.

Drawing the Path
09.23.2009

Christopher Alexander, *The Nature of Order: An Essay on the Art of Building and the Nature of the Universe, Book 1—The Phenomenon of Life* (New York: Oxford University Press, 2001).

Julia Cameron, *The Artist's Way: A Spiritual Path to Higher Creativity* (Los Angeles: Jeremy P. Tarcher/Perigee, 1992).

Betty Edwards, *Drawing on the Right Side of the Brain: A Course in Enhancing Creativity and Artistc Confidence* (Los Angeles: Jeremy P. Tarcher/Perigee, 2012).

Friedrich A. Kittler, *Literature, Media, Information Systems: Essays* (New York: Routledge,1997).

John Daido Loori, *Riding the Ox Home: Stages on the Path of Enlightenment* (Boulder: Shambala, 2002).

John Daido Loori, *The Zen of Creativity: Cultivating Your Artistic Life* (New York: Ballantine Books, 2005).

Sharon Louden, ed., *Living and Sustaining a Creative Life: Essays by 40 Working Artists* (Bristol, UK: Intellect Ltd, 2013).

David R. Loy, *The World Is Made of Stories* (Somerville: Wisdom Publications, 2010).

ACKNOWLEDGMENTS

I want to first acknowledge Vincent and Emily Horn for helping me connect my creative and contemplative practices. More than giving me teachings and supportive words, they invited me to speak and hold a workshop at the Buddhist Geeks Conference in 2014 that led to the publication of this book. I am grateful for their open minds and their willingness to see and allow many paths.

I am grateful to Parallax Press for publishing my work. I especially thank my editor, Jennifer Kamenetz, for her unwavering, upbeat attitude that kept me going. Thanks also to my publisher, Rachel Neumann, for supporting art and meditation; Terri Saul and Debbie Berne for their impeccable production and book design, which is more beautiful than I could have imagined; and Nancy Fish, Parallax's marketing director, who set the project in motion.

I have been able to have a career in the art world, be included in numerous museum collections, and find a voice in my work through the efforts of Sandra Gering, my art dealer for over twenty years, who has never stopped believing in my work and not only supports but also encourages its growth and change. I want to thank her and her staff over the years: Russell Calabrese, Marianna Baer, Laura Bloom, and Julie Bills who have each made contributions to the success of my artwork.

My thanks to the numerous universities and arts institutions that have created spaces for me to show art and speak publicly about my practice. I especially thank Pam Turner at Virginia Commonwealth University, who hired me to teach my first graduate seminar about creativity; and Bruce Wands, chair of the MFA Computer Art Department at the School of Visual Arts, for giving me an artist-in-residence position to develop "the source of creativity" as a workshop.

My thanks and appreciation to Julie Smith David, Jenny Johannesson, Merlin Wellington, and all the online daily practitioners who have showed me so many ways to create and the significant impacts of daily drawing on daily life.

More thanks to Uri Dotan, Georgia Marsh, David Kadish, Earl Davis, Nikita Mikros, Carrie Pollack, David Horton, and all my many teachers, friends, and students who stay in touch to keep the discussion of creativity alive.

I want to thank Louise and John Simon for being amazing parents. I love you and I love knowing you are my biggest fans. Thanks to Joan and Ed Gencarelli for winter refuge and summer help. More family love to Steve Seebol and Elizabeth Kahn.

I owe an even greater debt of thanks to my children, Kaleo and Dennery, for allowing me to spend so much time at the studio but always being happy to see me when I get home.

I am grateful for my wife, Elizabeth, who does so much for so many people—especially me. I could not ask for a more supportive partner, one whose talents make my life complete. Thank you!

Finally, gratitude to the creative source for always flowing. I am lucky to be able to offer this book and my work to a wide audience. The art emerges from a deep commitment to drawing that started as research but became a spiritual practice. It is my sincere hope that making drawings as a vehicle for self-knowledge will benefit everyone.

John F. Simon Jr. is one of the pioneers in the development of Software Art. Since the mid 1980s, he has been renowned for articulating the use of code in digital and multimedia works. He is at the forefront of the community of artists and curators who created the first wave of software applications, web-based projects, and digital approaches to art making, which continue to expand in new directions every year. As an example, in 2011 Simon completed an app for Icelandic singer Björk's new album, Biophilia; the first app album ever created.

Simon draws every day. His "Divination Drawings" are a years-long practice that includes over 2700 drawings posted online at www.iclock.com. This daily introspective, improvisational drawing is Simon's meditation practice. The images created are source material for larger works and his engine for artistic growth. Drawings from the "Divination" series begin intuitively; a pencil drawing or watercolor is started and then guided by the unconscious thoughts and emotions of that day. Simon's references include the scientific, spiritual, and natural worlds, with mathematics usually playing the connecting role. Where many people see technical proficiency, others see art historical references, the beauty of scientific minutia, and the delicate nuances that occur from years of color studies.

Simon's seminal work "Every Icon" was included in the Whitney's Biennial Exhibition (2000), and his artworks can be found in the permanent collections of The Whitney Museum of American Art, The Solomon R. Guggenheim Museum, The Museum of Modern Art in New York, Collezione Maramotti, The Brooklyn Museum, The Los Angeles County Museum of Art, and The San Francisco Museum of Modern Art, among others. In October 2005 the Whitney Museum of American Art and Printed Matter published Simon's artist's book and software CD *Mobility Agents*, based on the notebooks of Paul Klee.

John F. Simon Jr. holds an MFA degree from the School of Visual Arts in Manhattan and a Masters degree in Earth and Planetary Sciences from Washington University in St. Louis. He is represented in New York by Sandra Gering, Inc.